Introducing Op Art

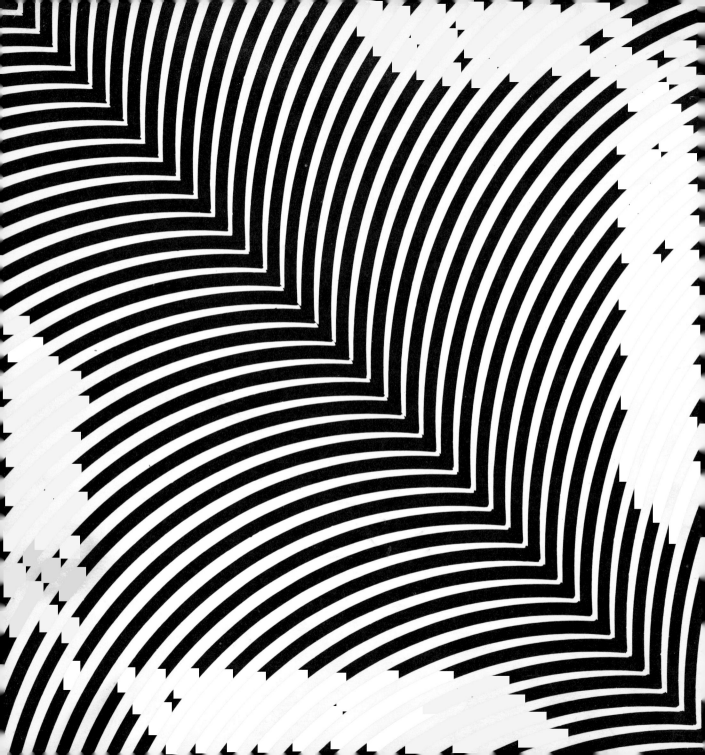

Introducing Op Art

John Lancaster

with contributions by

Theo Cowdell
David Palmer

B T Batsford Limited London
Watson-Guptill Publications New York

© John Lancaster 1973

First published 1973
Reprinted 1974
ISBN 0 7134 2438 9

709.04
LAN

757043

Library of Congress Cataloging in Publication Data
Lancaster, John
Introducing Op Art

Bibliography: p.
1 Optical art. I Title.
N6494.06L36 709'.04 72–10428
ISBN 0–8230–6267–8

Filmset by Servis Filmsetting Limited, Manchester
Printed in Great Britain by
The Anchor Press Ltd,
and bound by Wm Brendon & Son Ltd,
both of Tiptree, Essex
for the publishers
B T Batsford Limited
4 Fitzhardinge Street, London W1H 0AH and
Watson-Guptill Publications
One Astor Plaza, New York, NY 10036

4

Contents

To Janet

Acknowledgment

I should like to express my gratitude to all who have helped to make this book a reality. Special thanks are due to my wife for her patience and understanding during the long period of preparation, as well as to Theo Cowdell, art historian, and David Palmer, art adviser, for their particular contributions, and Douglas Lawson who has been responsible for the bulk of the photographic material used throughout the book. To Hugh Collinson, Guy St John Scott and Fred Morgan I am grateful for their valuable help in the discussion of preliminary ideas and the correction of some of the earlier drafts of the manuscript. I must also thank Ray Thorburn, op art painter from New Zealand who discussed his ideas and methods of working with me and allowed me to reproduce one of his paintings; staff and students in the Visual Studies, Science and Mathematics Departments of St Mary's College of Education in Cheltenham; teachers and children at Bishops Cleeve Infants School, Gloucestershire; pupils of Hreod Burna Secondary School in Swindon, Wiltshire; pupils of the Academy of the Sacred Heart in Montreal, Canada; Sister Kimi Katano of the International University of the Sacred Heart in Tokyo, Japan; the Librarians at St Mary's College and the Gloucestershire College of Art and Design, Cheltenham; Mrs Jane Gabrielle Scott, textile designer; tutors and participants on the Easter School in the Visual Arts directed by the author at the Gloucestershire College of Art in 1970; the Department of Photography at that college; Mrs Iris Morgan for her invaluable secretarial assistance; those museums, art galleries, publishers and artists who have allowed work to be reproduced, and, finally, Thelma M Nye, my editor, who has been exceedingly patient and encouraging.

JL

Cheltenham 1972

Preface

Reality is more than the thing itself. I look always for its super reality. Reality lies in how you see things.

<div align="right">

Pablo Picasso

</div>

The eye as an optical instrument does not always translate 'true reality' from the retina to the brain. This phenomenon has concerned many artists throughout history, both as a problem of simple translation and as a scientific principle governing reality and illusion. In this context della Francesca's fanatical involvement with perspective and Seurat's passion for optical colour mixing come readily to mind.

Whereas in the past an 'art form' or 'movement' took many hundreds of years to develop and only changed through the gradual acceptance of a new medium or a change in religious doctrine, Op Art, an abbreviation for Optical Art, can be seen almost in its entirety. However, this does not mean that it has already become outdated. The study of op art is the study of the behaviour of matter and consequently demands an interest in colour chemistry, mathematics, optics and kinetics, as well as the study of weaving and hard-edged painting.

What is most relevant when assessing the value of op art as a study within education is that we have, by definition, a true genre of twentieth century art which can be easily understood by children. All they have to do to understand the basic principles behind optical imagery is to look at the shimmering effects created by black railings or the optical impact of present day typography.

This immediacy is, I feel, most important when evaluating op art as it allows this particular art form to be accepted by the modern student. His world is saturated with optical decoration and has a music form which is both discordant and in essence transitory.

In the mid sixties the Electric Circus in New York, followed by every discothèque in the Western world, created a link between pop music, light and visual effects to create an environment of sensuous noise. In turn singers like Jimi Hendrix used all these facets of optical imagery to pervade and stimulate the senses, and the parallels between this pop movement and op art are obvious.

Although the implications of this 'scene' were not all desirable, it did establish a positive link between fine art and pop culture and almost for the first time one could see simultaneously examples of op art on show in major galleries, as well as being used on record sleeves, plastic carrier bags and Woolworth's ear-rings.

The content of art education must be seen to be of relevance, if it is to be accepted by the modern adolescent. For this reason alone one sees op art, in all its facets, as a very important part of modern interdisciplinary art teaching.

Guy St John Scott

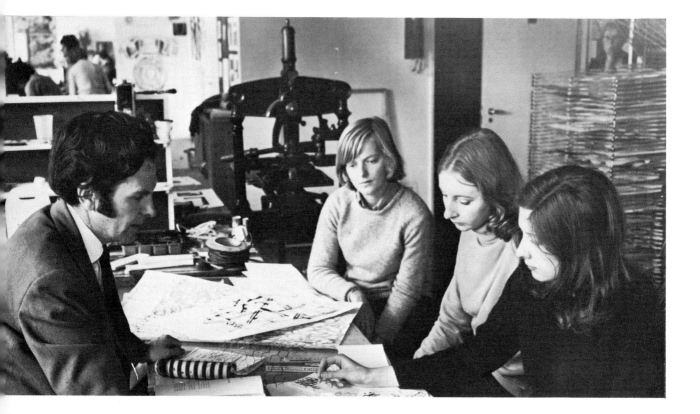

1 The author discussing work with students

1 Setting the scene
Op art and its related subjects

Op art is one of the most interesting facets of the art of this modern world of computerisation and mass production; but it is a sophisticated facet which seems to capture the very essence of industry's constantly moving mechanisms by means of what is generally termed 'hard-edged' imagery. In a peculiar way its optical patterns also reflect dynamic sensations evoked by the flickering imagery of cinema and television screens, whose moving forms can often be bemusing or even hypnotic to the viewer. Op art pictures contain inherent dynamic yet illusive qualities which are real one moment, and unreal the next, and which give its patterns the appearance of constant motion.

This form of visual expression certainly contrasts sharply with much fine art preceding it in this and earlier cultures, and is characterised by hallucinations of visual movement. These hallucinations are created deliberately by the artist when he juxtaposes his clinically produced lines and shapes in sharply contrasting tones of black and white, or in subtle hues of colour, on a physically static ground so that the resulting images seem to be mysterious, irritating and perplexing to our eyes and brains. Op art pictures make us look at them. They compel us to look away. They demand that we look back again. And therefore we could be excused for calling op art 'the art of visual irritation'.

When the spectator observes optical drawings, prints or paintings, he reacts: it is as if he is forced to do so. Op art does something to him, and its visual components, producing quivering optical forces which seem to struggle ceaselessly to burst free from the confines of the picture plane, tend to worry him, while demanding what Cyril Barrett describes as 'viewer participation'.[1] The viewer either likes op art, or he dislikes it. He is not allowed to be impartial. Op art can move him emotionally, but at times it can confuse or perplex him with its constant flickerings.

It is interesting to observe that most optical paintings have similar qualities to music. Indeed, we might even describe Op art as *visual music* for it communicates by means of visual tunes in which,

[1] See *Op Art,* page 104, by Cyril Barrett, Studio Vista, London 1970

as in music, the organisation of dynamic tensions, vibrations and patterns are vitally important factors. We also discover rhythmical innovations, contrasting qualities and both gentle and violent undulations in these works which are quite different to those of more traditional forms of art: those, for example, of landscape or portraiture which give us visual representation; for, in contrast, op art is completely abstract and with no suggestion of the material image.[1]

The very essence of this form of visual expression seems to be paralleled also in mathematics. Perhaps op art is really a form of mathematics, just as it would appear to be a form of music. Stravinsky, talking about his work as a musician explains that the forms which he uses in his music are '... mathematical thinking and mathematical relationships ...', and stresses that in his view '... the way composers think, the way', he says, 'I think, is not very different from mathematical thinking'.[2] Does the op artist do the same as Stravinsky when he manipulates mathematical ideas and concepts in producing his visual hallucinations? He uses pure mathematical shapes and geometric forms when he paints and arranges these in relation one to another in composing his pictures. Bridget Riley, one of the leading British exponents of op art, works out her preliminary designs on squared paper (see *figure 2*). This can be likened to the 'lined score' used by the musician and is the pre-determined, mathematical grid on which she composes her visual music before her optical patterns – usually painted in black and white – are transferred to larger panels of board or canvas so that the increased scale is impressive and the mathematical inferences more apparent.

We might be excused for asking: 'Is Bridget Riley really an artist? Is she a musician? Is she a mathematician? Is she all three? Is she, on the other hand, a scientist?' Maurice de Sausmarez says that there is an apparent detachment of the op painter from the creation of the actual work of art, which might have been 'produced by machines' – an interesting sentiment in an age of increasing computerization and machine-dominated living that links with a

[1] See Michael Seuphor's book *A Dictionary of Modern Painting,* Methuen, London 1960, for more data on abstraction in art
[2] Further reference may be made to *Stravinsky in Conversation with Robert Craft,* page 34, Pelican Books, Harmondsworth.

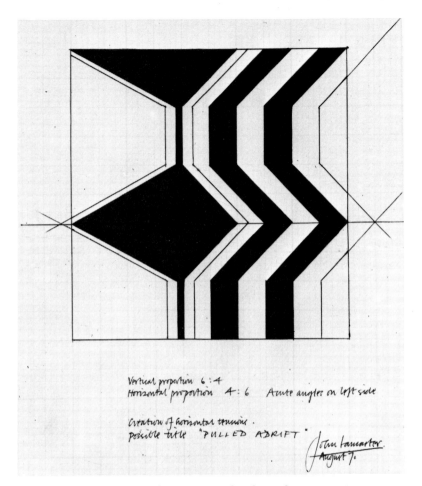

Vertical proportion 6:4
Horizontal proportion 4:6 Acute angles on left side

Creation of horizontal tension.
possible title "PULLED ADRIFT" John Lancaster.
August 7.

2 *Pulled Adrift* Sketch for a painting by the author

similar point made earlier in this chapter.[1] We can therefore be
excused for questioning the validity of this form of artistic ex-
pression which could probably be produced by the machine
operator just as easily as by the artist – an arguable but valid point.

Ray Thorburn, a New Zealand op art painter uses a basic modular
system in creating his pictures and is primarily concerned with
relationships. Each of his paintings consists of a number of separate

[1] *Bridget Riley,* page 18 by Maurice de Sausmarez, Studio Vista, London 1970.

units which can be arranged to suit the space surrounding them (see *figure 3*). His painting, entitled *Modular 1, series 3 1971*, consists of nine units of 100 cm × 100 cm (40 in. × 40 in.), each with a differently coloured background that is related tonally with the others, and with alternative orange over pink, pink over orange lines enhancing the geometric image. A contrasting colour is provided by the single vertical and horizontal lines in each panel which give the painting a feeling of total unity.

Thorburn's idea is that the modules can be hung independently, or in any combination, by the viewer, and this allows the viewer to participate in composing the final image. He is also concerned that when the disparate parts of a painting are hung in certain combinations the juxtaposition of lines and colours will create an illusion of movement, and yet when the same set of units is re-arranged, that the image will appear to be perfectly still. When commenting on Thorburn's contribution to the 1971 Sao Paulo Bienal, Melvin Day, the New Zealand Commissioner, recognised the optical overtones in the paintings. He '. . . uses colour in a vibratory, even optically disturbing way . . . [and his] . . . statements are at times rhetorical, but in general, a dialogue between object and perceiver,' he writes, 'the basic geometry of much of the work coming, in part, from the commercial technological world'.[5]

This is a cogent point, for it is apparent that the technological world in which we live is reflected in op art and in considering visual relationships, whether on a small or a large scale, we must take our surroundings into account. The environment is constantly changing. At times this change is slow, but at others it is rapid and it affects ordinary people who must realise that this is happening. People are responsible for the changes which are taking place now and *you*, the reader, might be involved in decision-making and change at some future time. Common sense, intelligence and

3 *Modular 1* (Series 3, 1971) An op painting by Ray Thorburn, a New Zealand artist, exhibited at the XI Bienal de Sao Paulo. It consists of 9 units of 93 cm × 93 cm (40 in. × 40 in.). Each background is a different colour, but tonally related with the others, and consists of alternating orange over pink, pink over orange lines. The only constant colour is the single white horizontal and vertical line in each panel.

13

responsible attitudes are needed if changes are to be good ones and with relevance to the needs of future generations, and they must be made with concern for good design. Does op art belong in this everyday world? Will it be a lasting phenomenon? If technology is a part of op art, is op art a part of technology? And can it really be appreciated by the mass of ordinary citizens? It certainly makes us use our eyes and it causes us to think, but do we know how to see with 'thinking eyes', that is, to combine the eye and mind in an effort to understand?

When we pick up an everyday thing such as a newspaper we immediately find examples of optical imagery and the pages of type, made up of many lines of closely related letters, seem to have their own 'living' dynamism. Specifically designed lettering (*figure 4*) or even crossword puzzles catch our eyes and force us to look again with more interest; and we cannot help but be attracted by advertisements such as the one, for example, selling *Gulf Oil* (*figure 5*).

Footballers can recognise their team-mates more easily if they wear striped shirts. We could also take air mail envelopes (*figure 6*)

4 Lines of closely juxtaposed lettering causing optical fluctuations

5 Gulf Oil advertisement
6 Air Mail envelopes

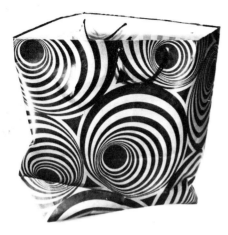

7 Paper carrier bag

8 Op art in fashion

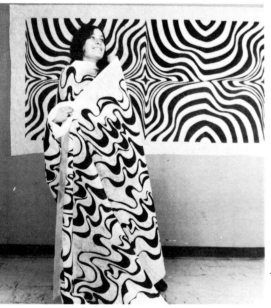

◀ 9 Optical screen prints on simulated paper fabric done by
participants on the Easter School in the Visual Arts, Gloucestershire
College of Art

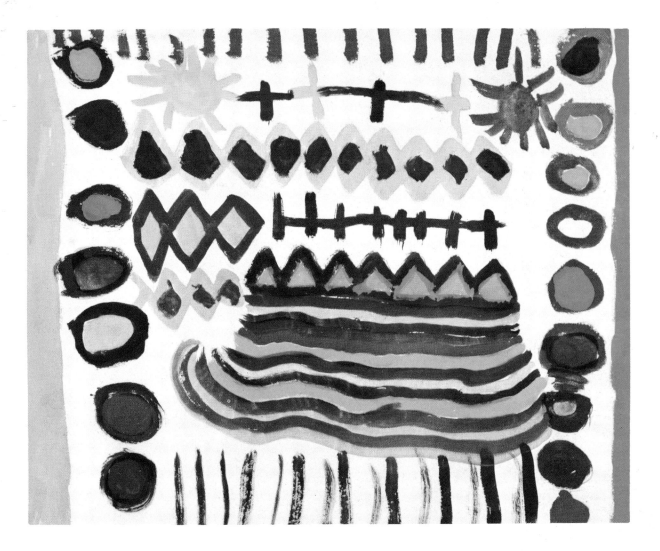

Plate 1

This painting by a young child contains dominant
optical qualities used subconsciously

as a good use of such patternings, for they have been designed cleverly, after ergonomic studies of a working situation, so that mail can be sorted easily and quickly. Such pragmatism is reflected in the use of optical imagery on roads and motorways where direction signs need to be bold and distinct so that a driver approaching at speed can see them at once. Black and white road signs catch the eye and then often give precise *pictographic* instructions for the driver to follow. But what is interesting, and yet frightening, is the fact that white stripes painted on roadside trees along many fast highways in France and Germany have been found to cause hypnosis and blackout in drivers as, indeed, can white lines on the surfaces of our own motorways as they rush continuously towards them as they drive at speed. In such cases, optical effects are controlling persons and are therefore dangerous.

Op art is an example of the art of our time that is now instantly recognisable in the paper shopping bag (*figure* 7) and plastic jewelry bought in any department store. At a more serious level, though, the professional fashion designer is ever conscious of the effects of stripes (*figure* 8) and oscillating forms. When designing women's clothes he will use patterns of vertical stripes to make fat ladies appear thinner. If they were to wear 'hooped' dresses they would appear to be fatter. Even before op art the textile designer was conscious of the design of drapery and the use of optical tricks (*figures 9 to 11*): for example, vertically striped curtains can make a room look more lofty than it is.

11 Base relief experiment, using optical effects, as part of a project concerned with three dimensional weaving by Jane Gabrielle Scott

10 Photographic effects used as a starting point for a textile design by Jane Gabrielle Scott

The communication media of the modern world, including printing (*figure 12*), advertising, the cinema and television, use graphic imagery which has spontaneity and directness. This visual force, or 'POW', is often optical in nature and strikes the observer with a vibrant dynamism. It seems to be impelled at us as a kind of 'happening' and we can see it in the high street, in the home, in shops and stores, when we travel by the underground railways in London, Paris or New York and now, regrettably, in the quietest of country villages where unsightly yellow lines indicate *No Parking* areas. We cannot escape it. Adolescent 'fun culture', with its strong affinity to pop music and Carnaby Street fashion, also vibrates with optical art of all kinds for it appeals to youthful senses through its visual impact (*figure 13*).

Our earliest ancestors, too, were well aware of the potency of artistic imagery in pre-historic times when they hunted wild animals for food and clothing, and scratched marks on pieces of stone, wood and bone; and primitive people today still decorate

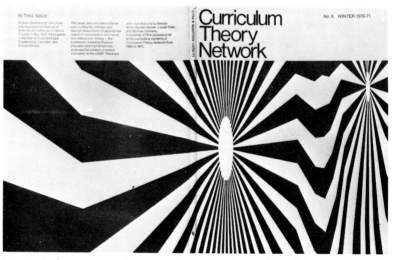

12 Periodic movements are produced by the optical design on this book cover

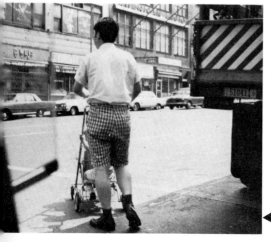

◀ 13 Quivering sensations on a pair of shorts and the back of a truck in China Town, New York

18

their own bodies with coloured patterns and extend their creativity to the decoration of their weapons, boats and clothes. Some of the patterns primitive people use are marks of an optical kind and include zigzags, concentric circles and repeated chevrons whose effects are often visually vibrant. Did they, like us, look at the patternings of tree branches against a bright sky? If so, they would find such imagery interesting and of an optical kind.

Although man has used optical patterns for a long time, op art itself has a comparatively recent history. This subject is dealt with in section 7, and helps to place this art phenomenon in its historical context, as well as providing some useful references.

It is important to know something about the workings of the eye, and section 5 gives a scientific description of this wonderful instrument which provides us with the power to see while making things visible to us. This section gives a fairly simple explanation of how the eye works, and how it allows us to experience the visual sensations coming to us from objects around us, for it shows us shapes, patterns, colours, textures and forms, and a little knowledge of how it manages to achieve this will help us to understand why it reacts as it does to optical art; to the perfect camouflage of a zebra or tropical fish; or to the flickering effects produced as we run quickly past a row of vertical iron or wood railings (*figure 14*).

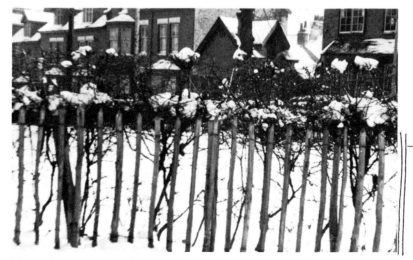

14 A simple wooden fence

Section 4 is devoted to *making* and *doing,* and this should help to stimulate original creativity. It is hoped that readers will be encouraged to try out some experimental work for themselves; indeed, I am sure that a real understanding of the subject will only result when reading and study are integrated with creative involvement. For this reason a number of ideas are proposed which could lead to more personal development and as the simple logic underlying op art has been discussed this will assist the reader in his experiments with cheap materials. Some of the more sophisticated experiments, however, are meant to tax the ingenuity of ambitious young artists, scientists or mathematicians and should lead to a deeper personal inventiveness and understanding.

It is hoped that more interest can be provoked in this fascinating subject. The book should appeal to young children, to secondary pupils and to student teachers in colleges and university departments of education. If it leads to the trying out of ideas and visits to galleries where art is on display, it will have succeeded in its main purpose. If it assists you to use your eyes a little more acutely, it will have been more than worthwhile.

Modern art and mathematics

It is fascinating to realise just how much our lives depend on, and are influenced by, mathematics. The simple abilities to count and to use money, to tell the time of day and to weigh and measure things, all depend upon mathematical principles. When the Renaissance established the rules of illusion it was natural that those rules should be couched in mathematical terms. Even before mankind began to concentrate upon producing illusions, men had always preferred a sense of order and balance in their art and this was often of a mathematical kind. The earliest art forms may be said to represent a striving for a more controlled and ordered picture of man's surroundings; perhaps this gave him a sense of security.

Mathematics is essentially an 'abstract' science. A multiplication table remains a very abstract system until numbers are related to certain objects. That is, when we say that three multiplied by three is equal to nine, we could be talking about nine of anything unless we specify the actual objects we have in mind, eg nine chairs. But when we are talking only in terms of numbers (nine of anything)

those numbers remain 'abstract'. In his book *Abstract Painting**,
Michael Seuphor reminds us that in a sense all painting is abstract
because, as Maurice Denis has said, any picture is always a flat
physical surface no matter what illusion of depth is created on that
surface. The picture *cannot be* the real object from which it was
'abstracted'. When modern abstract paintings emerged therefore,
it is not surprising to find some painters developing mathematical
ideas in their art.

* See 4, *Notes for further study*

During the early nineteen-twenties, Piet Mondrian (1872–1944)
the Dutch painter, developed a style of painting that used only
straight, horizontal, and *vertical* black lines and *rectangles* of three
primary or basic colours (red, yellow and blue) upon a white
surface. His ideas were influenced by a quasi-religious movement,
called Theosophy, originating in New York.[1] Theosophy interested
intellectual circles during the last quarter of the nineteenth century
and the first quarter of the twentieth. The movement believed, like
Hinduism, in the impermanence and even unimportance of the
world which we experience through our senses. The 'new form
structure' of Mondrian's pictures, with their mathematical and
geometrical precision, is the result of an attempt to symbolise the
spiritual, underlying structure of the universe.

At the same time a cubist[2] painter, Juan Gris (1887–1927) was
approaching the use of mathematics in a rather different way. Like
Plato he sought to express the truth of objects, not by drawing them
illusionistically in perspective, but like a draughtsman drawing an
engine component, or a house. He would resolve the profile view of
a bowl as seen from the side with the plan view as seen from on top.[3]
Thus Gris' paintings can sometimes be read like a blueprint, where
an engineer can measure an object's height, width and thickness
from a schematic drawing.

With the increasing use of technology mathematics affects our
lives to an unprecedented extent, and some computer languages are
symptomatic of this trend. Yet Jeffrey Steele pointed out in a lecture
to students[4] that the human mind is still Man's greatest and most

[1] Founded by Madame Blavatsky in New York in 1875. The influence of extra-
European ideas has become a familiar feature today – reference George Harrison
of the Beatles and his interest in Indian music.
[2] Cubism (1907–14) never did away with reference to seen objects.
[3] See *Le lavabo*, 1912. Reproduced in John Goulding's *Cubism*, Faber 1959.
[4] At Gloucestershire College of Art and Design.

complex computer. Steele's own work relies considerably upon the use of systems. In a sense science relieves one of uncertainties. That is to say, we all understand and see things by trying to relate experience to a 'system' suggested by the mind. Thus perspective (the understanding of depth through the use of geometric vanishing points), is a system which enables us to understand the idea of depth and a spatial relationship. Mathematics, in the sense of certain systems of logic and thought, can offer us methods and attitudes of seeing.

Modern art and music

When legend ascribed to Pythagoras[1] the invention of both mathematics and music it was no coincidence. In order to record, and later to compose music in the conventional sense, music had to be measured in notes, scales and keys. The word 'harmony' has been used since early times in connection with art, music and mathematics. Seurat wrote that 'art is harmony' and himself used analogies. The vocabulary that is frequently used in the texts found on the sleeves of long-playing records of classical music will be found to employ words applicable to painting as well as to music, ie tone, colour, line, etc.

In the nineteenth century Goethe (1749–1832) associated certain sounds with certain emotions. He is now sometimes regarded as the high priest of Romanticism[2] – a general cultural movement which had as its cult the importance of emotions to the individual – and which founded many attitudes which still persist in modern society. Further developing the analogies which Goethe made, the Russian artist Kandinsky applied them to his own theory of painting. Parallels between colours, sounds and emotions are to be found in his own work, particularly in his book *Concerning the Spiritual in Art,* 1912, written shortly after he made his first abstract paintings. Music is after all a relatively abstract art form, creating moods in a similar way to colours. Furthermore, as in painting, music requires structure in its composition. And any form of structure depends upon a growth process analogous to mathematics.

[1] The Pythagoreans were a school of Greek philosophers active before Socrates (died 399 BC).
[2] A movement subscribed to by a host of artists throughout Europe, including Wordsworth, Byron, Stendhal, Walter Scott, Delacroix, etc.

An important aspect of much music this century, particularly popular music, has been the increasing emphasis upon rhythm.[1] Percussion has come to play a more important part; and of course rhythmic structure is applicable to both music and to painting. Op art can readily be looked at in this way.

The possibilities of exploiting such relationships between different art forms has been given considerable attention of late, although parallels between one art form and another have been used in previous centuries, ie the Renaissance and Mannerist epochs. Today, with modern theatre, concrete poetry, the arts laboratories, there is great interest in these ideas.

Modern art and psychology

The work of Siegmund Freud (1856–1939) and Carl Jung (1875–1961) early this century contributed much to the study of the human mind. The phrase 'Beauty is in the eye (or the mind) of the beholder' is particularly apt when one comes to consider how psychology should come to influence 'aesthetics',[2] that is the appreciation of beauty. *Abstraction and Empathy* by Wilheim Wörrington, published in 1908, is subtitled 'A contribution to the psychology of style'. Developing the work of theoreticians such as Lipps and Riegl, Wörringer believes that mathematical and geometric art forms have always been enjoyed by man because they offer a basic kind of enjoyment. (Think of the rhythm of the dance.)

One of the first movements to exploit this new interest in the subconscious areas of the mind was Surrealism, founded in Paris in 1924 by André Breton. You may be familiar with the dream world pictured by Salvador Dali (born 1904). Surrealist poets and painters seek to express aspects of the subconscious in pictures which appear unlikely, absurd or even frightening to a conscious mind but correspond to the illogical, irrational world of our dreams. These ideas have also been exploited by the modern cinema (Buñuel, Fellini and others) and in novels.

A development of psychology which has come to influence op art

[1] European interest in primitive art forms became pronounced early in the twentieth century.
[2] Aesthetics was first established as a discipline by Baumgarten (1714–62) in a book *Aesthetics of 1750,* and by Winckelmann (1717–68), the first art historian in the modern sense.

15 *Autre Monde* by M. C. Escher. Woodcut in three blocks.

in particular is Gestalt psychology. Mainly developed from the work of Wertheimer, Kohler and Koffka, it came to make a specific contribution to the visual arts. Rudolf Arnheim wrote two articles in the *Journal of Aesthetics and Art Criticism* in 1943 which should be of interest to the reader. These point out that recognition and understanding depend upon the eye and brain being able to grasp the basic 'structure' of objects very quickly. These structures, patterns, or *Gestalten,* immediately let the eye pick them out from the background. They are properties not just possessed by the interpreting eye-brain, but are also common to the objects which are being seen.[1] Here we have a key to op art. If this recognition process can be interfered with in the right way the eye and the mind will be presented with a surface that appears to move and to change. This is because the brain continually offers different solutions to the image. It is interesting to see how Arnheim's later work coincides with the interest in developing op art by Vasarely and others, although the word 'op' did not really appear until 1964.

Op art and modern abstract art

One of the most important and far reaching aspects of modern art is the degree to which the artists are trying to *involve* the spectator in the experience of the object. And this also applies to modern music, poetry, drama and other art forms. Spectator participation has been one of the conscious aims of many op artists. Instead of the spectator simply looking at the picture as an object, as something that is in a different world to his own and isolated by the picture frame, he is now encouraged to consider his own relationship and involvement with the work of art.

In the exhibition 'The Art of the Real' at the Tate Gallery in 1969, the paintings and sculptures made no attempt to represent any natural objects. A blank canvas, one can argue, is far more 'real' and truthful than a painting of a landscape or a crowd of people. The blank canvas does not pretend to be what it is not (ie a hole in the wall through which one sees a landscape or a crowd of people). The spectator, therefore, when faced with a blank canvas, is involved in a real situation, not an imaginary one. Similarly, in op art

[1] In this, Gestalt psychology differs from Kant's philosophy in that Kant believed that it is only the mind which superimposes a pattern or category onto the object, for 'Gestalt' is a quality presumed to be common to both mind and object.

the spectator is made conscious of the act of perception, the reality of seeing. One is reminded that art *parallels* nature and does not necessarily imitate nature, a point noted by Seurat and more recently by Stanczak.

Vasarely started working in abstract op art between 1931 and 1938, then again after 1951. The Venezuelan Soto (born 1923) also developed op paintings from the early 1950s. The *Groupe de Recherche d'Art Visuel* which included Le Parc and Morellet, was founded in Paris in 1960. In England, stimulated by the ideas of Harry Thubron in Leeds, interest in optical experiment spread significantly in the 1950s, and by the 1960s the work of Peter Sedgley, Jeffrey Steele and Bridget Riley was becoming well known.

Let us now move on to the next section in which is put forward a simple definition of op art. Some of the ideas and descriptive terms will be repeated in order to strengthen understanding and make the subject itself a little more meaningful, but it might be a sensible idea to keep a small notebook or journal in which to make sketches and notes. This would become a personal dictionary and useful source of reference.

2 What is op art ?

Op Art is a term now applied to a movement in painting which achieved its peak of popularity in the years 1965 to 1968. The fascinating and sometimes dazzling effects produced by these paintings result from the basic idea that the eye's greatest challenge is itself: the way in which it 'sees'. The movement received recognition by its representation in modern national collections.

Advances in many fields, such as science, philosophy and psychology, have contributed to the emergence of op art. Many of these ideas can be traced back to previous centuries. For instance, in the early seventeenth century the philosopher Descartes (1596–1650)[1] decided that reality must be thought of as being primarily related to the self: '*Cogito ergo sum*' – 'I think therefore I am'. In the eighteenth and nineteenth centuries much work was done on *how* people think, see and understand, culminating in many aspects of modern psychology and philosophy. These progressive ideas inevitably had their effect upon the visual arts, and a more detailed analysis of some of them is to be found in the historical section.

In all visual observation the eye itself simply responds to a collection of colours and shapes. The invention of the camera in 1826 showed that it was mechanically possible to reproduce the image perceived at the back of the eye at one moment in time and this was later extended into the field of cinematography, the beginning of modern cinema in 1897. Photography, however, does not offer any solution to the problem of how we recognise and understand the images which we see. Before the advent of psychology, around the turn of this century, some philosophers had succeeded in making contributions to this field. Kant (1724–1804)[2] had argued that each one of us possesses 'categories' of understanding with which all new experiences are resolved. If we had no previous idea of the function of a table, it is unlikely that we would be able to recognise a table when we saw one. 'Seeing' is a process of understanding as well as the physical action of actually seeing with or using the eye. Modern psychologists such as Rudolph Arnheim[3]

[1] Descartes' *Discourse on Method*, 1637. Objects are considered as ideas on the part of the self.
[2] *The Critique of Pure Reason,* 1781.
[3] Rudolph Arnheim published an explanation of Gestalt psychology in the *Journal of Aesthetics and Art Criticism* in 1943.

and scientists like Richard Gregory[1] have concluded that what we really see (in the sense of seeing and understanding) is a result of the way in which the brain interprets information given to it by the eye.

A similar process can be observed in the history of art. During the Renaissance (c 1400–1520) in Italy and Northern Europe, artists discovered a means of producing a camera-like image of the world around them. The works of Leonardo da Vinci (1452–1519) and Jan Van Eyck (died 1441) may be used to illustrate this. In the nineteenth century, however, the invention of the camera freed artists from the task of imitating the appearances of the world around them. Impressionist painting of the 1870s and 1880s roughly coincided with the introduction of the snapshot in photography. The Impressionists tried as far as possible to record what the eye saw at a particular moment in time. The painters that followed, however, realised that 'meaning' did not only depend upon the eye itself, but the way in which sight is interpreted. Photographic representation can be replaced by a symbolic[2] or diagrammatic one.

Since the work of the Post-Impressionist painters, Gauguin, Van Gogh, Seurat and Cézanne which was later followed by the Cubism of Picasso, Braque and Gris (1907–14) much modern painting has tended to emphasise the picture surface. After all, even a photograph is only a flat piece of printing paper with a pattern image on its emulsion coating. Most op art makes use of the duality between illusion and picture surface. The problem was stated clearly enough by Maurice Denis (1870–1943) who wrote in 1890 that before a picture represents any object it is essentially a flat plane covered in colour areas.

Optical art is a method of painting concerning the interaction between illusion and picture plane, between understanding and seeing. In Germany, the Bauhaus was founded under the architect Walter Gropius in 1919. It was active as a School of Arts and Design until its closure in 1933 due to Nazi pressure. As it matured it became representative of a more rational and analytic approach. Later its idea had a very considerable influence on art education

[1] See *The Eye and the Brain* by Richard Gregory, published in 1966.
[2] *Symbolism* was a movement in French art during the 1880s and 1890s.

both in the United States[1] and in this country. Naturally, such problems as outlined above came within its scope. Josef Albers (born 1888) who was first a student and later a teacher at the Bauhaus, has produced a large amount of work connected with optical problems. Many of his drawings and paintings can be looked at in a number of different ways. The brain has not been given enough information to interpret the image in any one particular manner (see *figure 16*). It is precisely this tantalizing, annoying and even sometimes aggressive quality which is so fascinating in op art. The

[1] During the 1930s Lazlo Molholy-Nagy (1895–1946) headed the new Bauhaus in Chicago. His book *The New Vision* was important in publicizing the philosophy and aims of the new art education.

16 *Structural Constellation* by Joseph Albers, Engraving No. 30, 1955 65 cm × 48 cm (25½ in. × 12 in.) One of a series of pictures it shows an 'impossible' geometric figure. The eye is unable to read the image consistently, and cannot decide whether to read the planes defined by the lines as coming forward or receding. Both explanations are possible. Since no light, shadow or colour is employed the brain is given insufficient information to decide on one particular solution

Denise René Gallery, Paris

movement first became popular in 1965 and for about three years was fashionable in a variety of aspects, influencing such fields as poster design, fashion fabrics, and interior décor.

Much of op art relies upon the scanning movement of the eye over the picture surface. This movement can be accelerated and disturbed by making up the surface design from a large number of slightly varied small shapes or lines. When this is carried out effectively the brain finds itself unable to impose one particular image but offers a number of different solutions at once. Both Victor Vasarely and Jeffrey Steele developed optical paintings of this type (*figures 17 and 18*). There is in fact some uncertainty as to who was the real originator of the movement critics quickly labelled 'Op Art'. Bridget Riley also started to use similar techniques in her painting.

Many aspects of op art require a very exact, apparently impersonal, technique in order to create the desired effect. Vasarely has drawn certain social implications from this. By getting rid of the personal 'handwriting' of the artist's brush, he hopes to discountenance the romantic tradition which sees the artist as a 'special being'. Much of the work by Vasarely, Steele and Riley (*figure 19*) actually uses rhythmic forms based on mathematical systems of progression. Some elementary examples of these are included in section 4, page 70.

17 *Supernovae* by Victor Vasarely 1959–61. 241 cm × 150·5 cm ▶ (95½ in. × 59¾ in.). The painting's basic grid structure itself is sufficient to animate the surface. After looking at it for a short time, small grey after-images will be seen at the intersections of the white lines. Although the design is symmetrical this may not at first be obvious. The light area top left is balanced by the dark top right. If one looks along the grid lines at an oblique angle to the page one will see that this effect is achieved by expanding or contracting the thickness of the white grid lines in these areas. A little lower down a horizontal line of black squares formed by the grid is animated by progressively forcing them into rhomboid shapes, and then back to squares again. In the lower section of the picture small black dots replacing certain black squares on the left, expand in size at intervals from left to right on a horizontal axis, effectively replacing lighter areas on the left with darker ones on the right *The Tate Gallery, London*

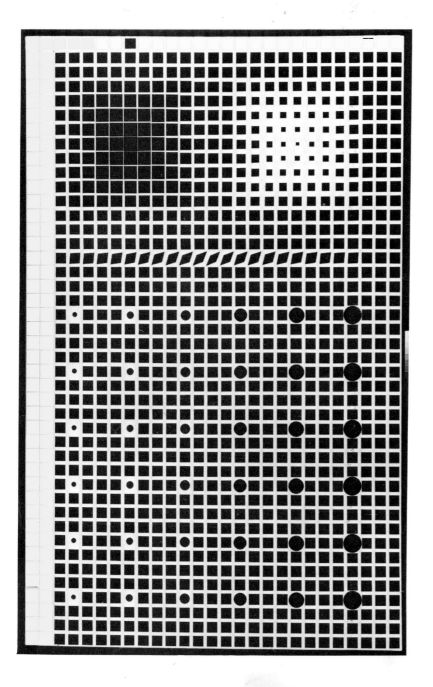

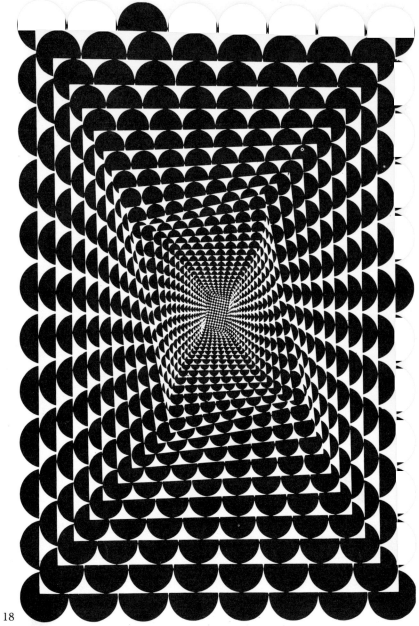

18

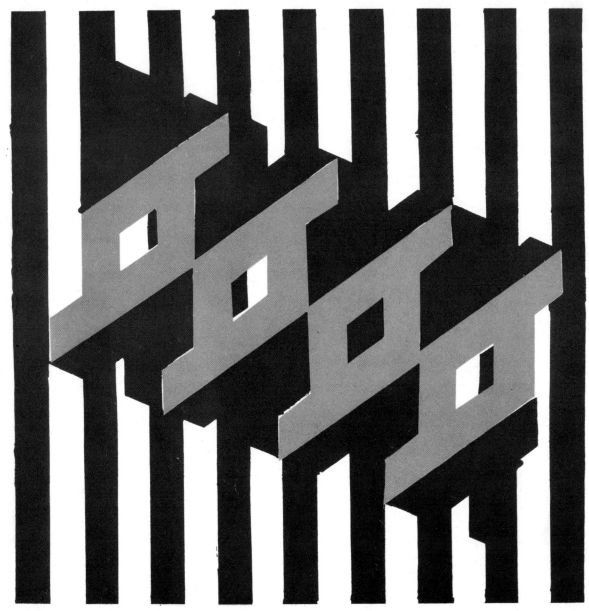

Plate 2

Black and Pink A two-colour screen printed by a
college of education student

19 *Intake* by Bridget Riley 1964 180 cm × 180 cm (70¼ in. × 70¼ in.)
This painting can be read both as black lines on white or white lines on
black. Despite the illusion of a three dimensional, undulating surface,
one remains conscious of the essential flatness of the picture surface.
Because of this one becomes particularly conscious of the way in which
one is interpreting the picture *Collection of John Powers USA*

18 *Baroque Experiment: Fred Maddox* by Jeffrey Steele 1964
152 cm × 101 cm (60 in. × 40 in.) One of the first popularly known op
paintings by Steele. It uses mathematical systems which are related to
his enthusiasm for the computer. Most of his paintings rely upon
progressions in number and measurement with progressive repetitions
which add much to the sense of movement. Earlier pictures were
confined to black and white but more recently colour was introduced
 Collection Hon. Anthony Samuel

It is not surprising that some of the most outstanding examples of op art used only black and white. A dazzling effect can be achieved without the complexities of colour. Colour, however, has its own optical potential. During the nineteenth century many scientists and artists contributed to colour theory, and Josef Albers has also worked in this field. Colours placed in certain relationships can be made to interact very brightly and can disturb the focus of the eye. All the artists mentioned above have developed work in colour as well.

Since op art gives sensations of movement it has sometimes been confused with kinetic art. As early as 1910 artists in the Italian Futurist Movement[1] had enthused over the machine as the typical twentieth century theme. Kinetic art as it evolved depends upon movement of a physical kind, often mechanical, either in the work itself, or on the part of the onlooker. The movement involved in kinetic art however, is of rather a different character to that produced in op art. In the latter, 'movement' results purely from the act of perception, and this is created by images on the picture surface.

[1] The Futurist Movement was launched in Paris, which was then the artistic capital of the world, in 1909 by a group of Italian artists led by Marinetti, seeking to embrace the new machine age, *cf* Reyner-Banham *Theory and Design in the First Machine Age.*

3 Visual dynamics of op art

Op art relies completely on visual dynamics or what might be described as *quivering illusions of movement,* for its effectiveness. Such optical oscillations occur when an interaction takes place between static images so that the viewer perceives a constant vibration or interchange of stimuli resulting from what is termed the *figure/ground* phenomenon, an expression referring to the unique relationship of graphic forms which, as perfectly still images, act upon each other and their backgrounds to produce apparent changes of position. Optical dynamism of this kind makes us aware of fluctuations in obvious lines of movement, varying lapses of time and irregular illusions of depth as it maintains ceaseless motion and rhythmical undulation. It allows optical imagery to fool our eyes and to give us feelings of visual discomfort, frustration, excitement and uncertainty.

The concept of *figure and ground,* then, and the juxtaposition of these phenomena are important to us in understanding or at least coming to terms with op forms of visual expression. These are its basic ingredients, just as hydrogen (H) and oxygen (O) are the ingredients of water (H_2O); and if there were such a thing as a mathematical formula for op art, this would probably be $im(f + g) =$ OA, where im = illusions of movement, f stands for *figure,* g is the *ground* and OA is an abbreviation for the term *op art* itself.

But let us examine this *figure/ground* concept further for it is important to all aspects of art, while being absolutely crucial to effective optical art. The creation of illusion – in which pulsating dark and light geometric compositions perplex the eye – is important, and the artist has found that black and white produce the best results. Why black and white? Cyril Barrett, in his book *Op Art,* explores optical effects in black and white and gives reasons for their use. One of these is that black and white tonal contrasts are so strong that optical effects are dynamic or even quite dramatic at times. 'Most optical effects', writes Barrett, 'can be achieved by the use of black and white alone', and 'one of the advantages of confining oneself to black and white is that it limits the complexities of the problem'.[1] So, black and white imagery is clear to

[1] Cyril Barrett *Op Art,* page 38.

see, its forms are well defined and their manipulation provides for a strong element of control and self-discipline. Michael Compton, another writer on this subject, when discussing the use of black and white in optical art says: 'The reasons for the adoption of black and white by so many artists are perfectly clear. Firstly, the extreme contrast and lack of shading or texture afford a maximum of the key optical effects, including after-images and moiré. Secondly, black and white form visually the simplest and most unequivocal binary system: yes – no. And thirdly, the omission of colour eliminates many emotive associations and so allows both the artist and the person looking at the picture to react solely to effects of configuration'.[1] This restriction is really most helpful for our purposes and allows us to accept the simple idea that in op art imagery whether this be in drawings, prints, designs for textiles or paintings, the *figure* will be either black on a white *ground,* or white on a black *ground*. In all cases the contrast between *figure* and *ground* will be at its maximum and most effective.

Let us experiment. If you look at *figure 20* you will see that it consists of a single black square, the *figure,* on a white page, the *ground*. What do you notice? Do you have the feeling that the square seems to be nearer to you than the *ground,* and that the white page itself is further away? Turn to a page of type and see whether a similar thing occurs when you look at the rows of black lettering on their white background. Do the letters, like the square, appear to come towards you? Now look at the five illustrations in *figure 21* where we have at (a) a single black spot (*figure*) on a white square (*ground*); at (b) two black figures, a spot and curved shape, on a white ground; at (c) a black square containing on it an inner square and concentric black circles, on a white ground; at (d) a single vertical black line on a white square; and at (e) a combination of black and other forms of a lighter tone on a rectangle. In each case the darkest shapes seem to be nearer to you than the lighter ones which seem to recede into the picture space.

Does this give you feelings of illusion or movement? Do any of the images seem to be aggressive towards each other? Do they irritate your eyes or seem to fuse into each other? When you look at *figure 22* do you experience an illusion of space, a visual throbbing

[1] Michael Compton *Optical and Kinetic Art* published by The Tate Gallery, London 1967.

Figure 20

38

21 (a) Black spot (*figure*) on a white square (*ground*)
 (b) Spot and curved shape – two black figures on a white ground
 (c) Large black square (*figure*) on a white square (*ground*)
 (d) Vertical black line (*figure*) on a white ground
 (e) Composition of various *figures* on a white *ground*
 Painting on canvas by the author

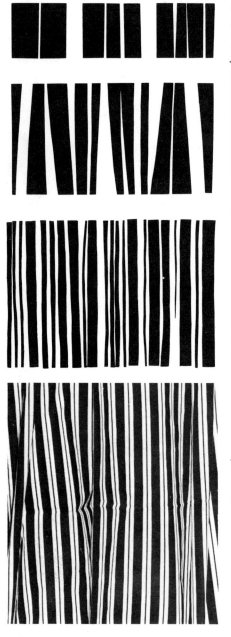

and flickering as the black and white lines interact? Look at *figure 22* again, staring intently at its centre, and notice that your eyes jump to and fro from *figure to ground,* near and far; from *ground* to *figure,* far and near, in an erratic search for rationalisation.

22 Combinations of lines causing visual pulsations and an illusion of space

The more closely such graphic forms are related the stronger seems to be their visual interaction and the more the optical forces pulsate and bewilder with their trembling, kinetic impressions. This is shown to good effect by the series of vertical stripes in *figures 23* and *24,* which make it abundantly clear that as the vertical stripes increase in number and length so the fluctuations of movement increase and the blacks and whites become interchangeable. See also *figure 25.*

23 Expansions on the *figure/ground* phenomenon
24 Visual oscillations caused by printed black and white stripes
25 Optical oscillations are produced by this large scale piece of mâcramé 244 cm × 122 cm (8 ft × 4 ft) by Jane Gabrielle Scott

This visual *to'ing* and *fro'ing* is also seen to effect in the series of printed red rectangles in plate 4, facing page 81, for as the eye looks at the regularly spaced shapes it begins to feel unsteady and swings from *figure* to *ground* in slight confusion. The series of squares in *figure 26* is not meant to be a pattern and shows only what occurs when tones vary, and the sketchbook drawings in *figure 27* show further developments on a similar theme. Both examples imply a slight unsteadiness in the observer who does not really feel too comfortable.

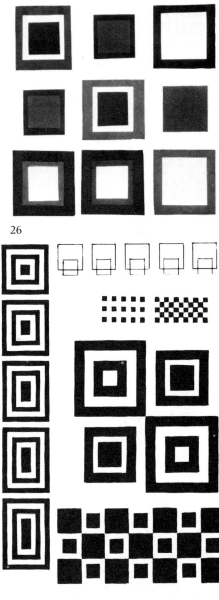

26

27 Experimental sketches based on squares

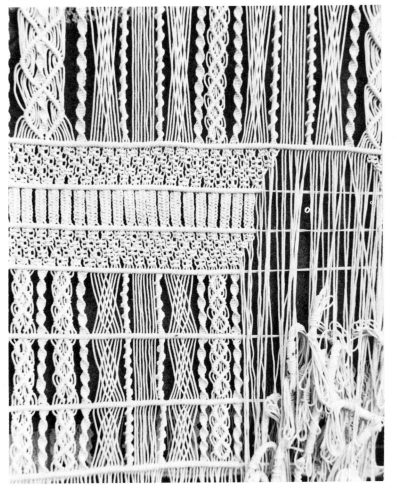

41

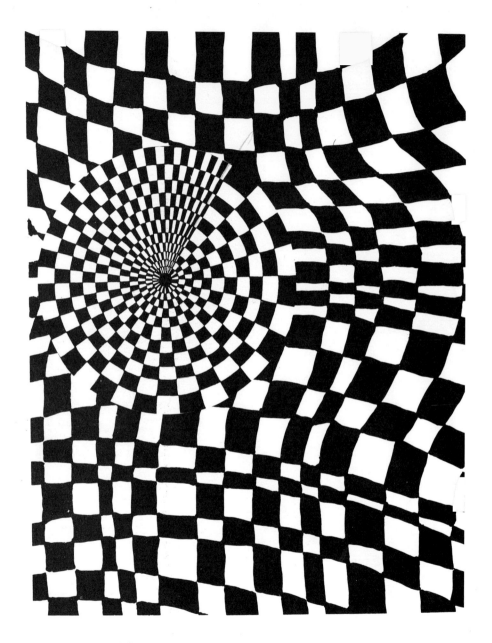

28 Developments on a theme of circles and squares

Illusions and visual fluctuations produced by the tonal contrasts and inner conflicts of squares and circles in *figures 28* and *29* show the *figure/ground* phenomenon working very well. Notice how the images tremble. Observe the sensations of periodic motion. Move closer to these patterns and experience the visual unsteadiness and increased visual irritation. This constitutes the phenomenon of *figure* and *ground*. It really explains itself. It is a personal experience. It is a visual response.

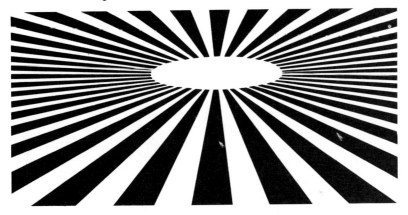

29 The pendulosity of some of the more closely related forms is very strong

Let us return for a moment to the simple logic evoked by the single image on its background, *figure 20*, when we discover an apparent movement backwards and forwards. With an increase in the number of images on the page (experiment by introducing other cut-out black shapes), there will be a fluctuation of identities between the various *figures* and the *ground*. This fluctuation, this uncertainty, this irrationality constitutes op art's visual dynamic, it is the keystone upon which op art depends; without it, it would accomplish nothing and be worthless.

4 Op art projects and experiments

This part of the book proposes a number of ideas for practical work. These have been set out quite simply so that they are easy to follow, and in every case they include a list of materials required as well as a set of instructions. It is hoped that the reader will develop the suggestions much further so that the practical work itself takes on an individual and distinct character.

Included are a number of brief comments made by students, and examples of work illustrate some of the ideas. This is only to show what can be done and should inspire the reader to do even better himself.

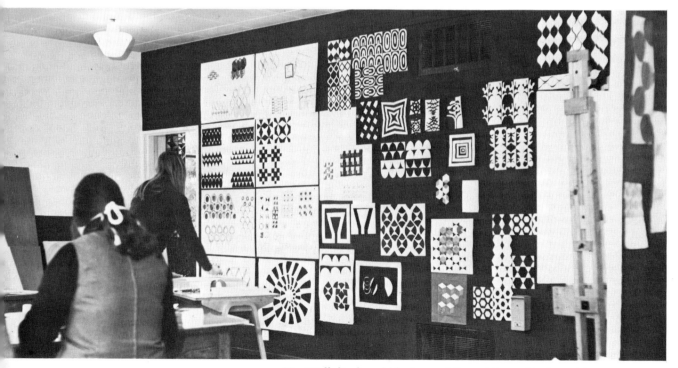

30 Well displayed black on white, white on black, making a professional exhibition of college of education course work
Photograph by the Gloucestershire College of Art and Design, Photography Department

PROJECT 1
Curving lines

Materials
Black and white paper, a rubber cement or acrylic-based adhesive (Marvin Medium), a black felt-tipped pen, tracing paper

Method
1 Cut a number of 'curving' lines in *three* pieces of black paper. These should be a
(a) square piece 10 cm × 10 cm (4 in. × 4 in.)
(b) rectangular piece 15 cm × 5 cm (6 in. × 2 in.)
(c) circular piece with a radius of 8 cm (3 in.)
2 Glue each of these down on to white paper and make sure that you allow some waves of white to show through.
3 Add some more 'curving' lines with your black pen.
4 Copy these designs on tracing paper and then experiment to see what happens when this is placed over the original designs. Try moving the tracing paper to different positions.
5 Write a few short comments describing personal reactions to the images made.
6 Do some line drawings.
7 Add ink lines to an earlier design.
8 Experiment freely.

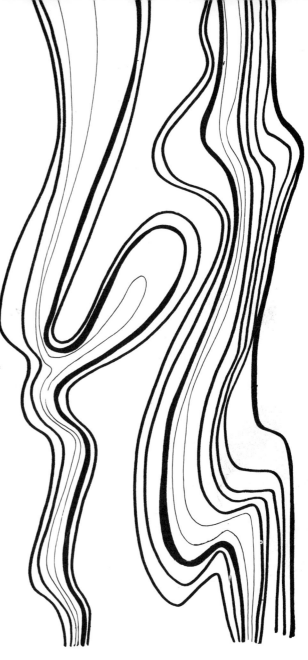

31 Line sketch by the author

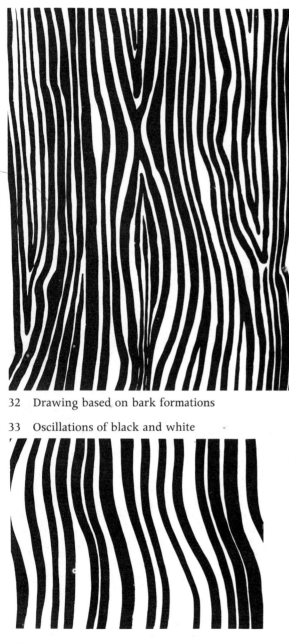

32　Drawing based on bark formations

33　Oscillations of black and white

PROJECT 2
Vertical waves

Materials
Black and white paper, black ink, pen or ball point, small brush, scissors, glue, aluminium foil, tracing paper, hardboard or fibreboard, wire, string, nylon thread

Method
1 Draw a rectangle or square on a piece of paper.
2 Mark off a series of points at irregular intervals along the top edge of this shape – some very close to each other and others widely spaced.
3 Draw wavy lines from these points and let these move down towards the bottom of the rectangle or square. Allow a few of these lines to the bottom edge and others meet to stop before they reach it.
4 Fill in alternate waves with ink, aluminium foil strips or coloured paint.
5 Develop two or three more ideas using aluminium foil, tracing paper, ink, paint, wire, string or thread – or combinations of these materials – on hardboard or fibreboard.

A student who experimented in this way with 'wave-like' shapes wrote:
> 'Having produced a pattern of curved lines and filled in the alternate waves in black and white, I then traced the pattern on to another sheet of paper . . . reversing the design and filling in opposing alternate waves . . . to achieve a mirror image. I found this produced different effects of undulations which were interesting. However, my eyes had some difficulty in focusing correctly and the undulations seemed to move and change their

appearance due, no doubt, to the fluctuations in attention.

'I went on to develop the idea further by tracing the design on to another sheet of paper, keeping the curved lines horizontal and then cutting them up by equidistant vertical lines. The new effect was quite disturbing to the eyes as they tried to focus on the verticals but were constantly drawn away to the horizontals.'

PROJECT 3
Horizontal waves

Materials
Black and white cartridge (drawing) paper, scissors, aluminium (kitchen) foil, poster or acrylic paints, coloured gummed paper, inks and brushes

Method
Follow the instructions carefully
1 Make a number of 'curving' cuts in a long strip of black paper.
2 Stick these on a sheet of aluminium foil – leaving spaces between each black strip – so that you are left with a series of undulating black and silver waves.
3 Repeat this using white paper and silver foil.
4 Introduce one or two wave-like lines into both designs using paint or coloured paper.
5 Develop the following *four* ideas further on the themes of:
Turbulence
Violence
Sharpness
Calmness

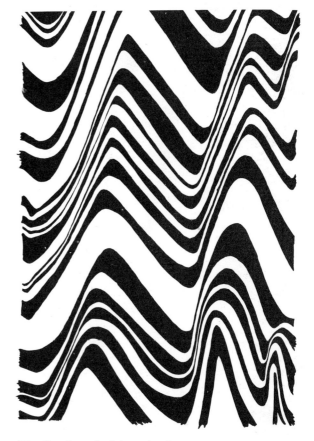

34 Gentle and violent rhythms

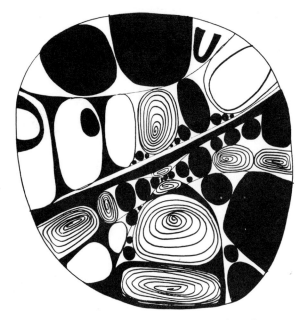

35 Orchestrated images based on spirals and other forms within a shape.
Ink sketch by the author

PROJECT 4
Spiral Idea 1

Materials
Black ink, white paper or card, strong glue, nylon thread, wire or thread and a black felt-tipped pen, a compass

Method
Follow the instructions carefully
1 Draw a large circle with black ink.
2 From the centre of this circle draw a spiral which gradually moves towards, and then joins, the circumference.
3 Make some more spirals within other circles and relate these closely so that the paper is covered.
4 Develop other ideas in which spirals and black, hard-edged shapes are used.

PROJECT 5
Spiral Idea 2

Materials
Strong card, hardboard or fibreboard, white and black string, glue, nails, thread, wire and nylon thread

Method
1 Use a piece of black string (made by dipping white string into ink) to form a spiral when it is glued on to the card or hardboard panel.
2 Add more spirals of thicker string to make a series which touch each other.
3 Glue a large number of nails (standing on their heads) onto the card so that these follow the spiral designs.
4 Now go on to be inventive by creating three-dimensional shapes with cotton, string, wire and nylon thread.

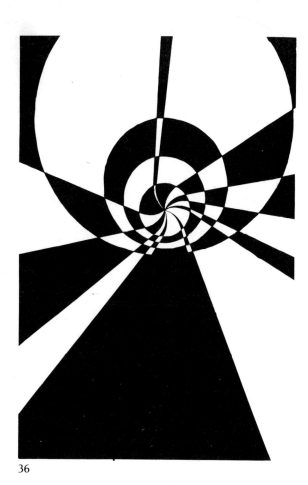

36

PROJECT 6

Developments with a circle

Materials
White and black drawing paper, pencil, ruler, compass, white and black gummed paper, scissors, sharp knife, 2 sheets of coloured paper

Method
1 Draw a circle (Circle 'A') on white paper with a radius of 10 cm (4 in.).
2 Cut out this circle.
3 Draw 50 isosceles triangles – each with a base of 1 cm ($\frac{1}{2}$ in.) and a height of 9·5 cm ($3\frac{3}{4}$ in.) – on the black gummed paper.
4 Cut out these triangles.
5 Arrange the triangles in the circle, with their bases on the circumference and their points towards the centre. Space them evenly.
6 Repeat this procedure, using black drawing paper as the 'ground' and white gummed paper to produce the triangular 'figures'. This will give you Circle 'X'.
7 Stick both circles on a piece of brightly coloured paper (bright green, red or blue), so that they almost touch.

Questions
Comment on the effect produced in each circle. How does Circle 'A' differ from Circle 'X'?
Try moving the paper from side-to-side with sharp, jerky movements and ask yourself: What is happening?

Variation
Instead of sticking the circles down on the paper place them on the turntable of a record player (phonograph) and allow this to revolve at differing speeds. If you have no record player you can pin the circles to a wall and spin them.

Questions

What seems to happen when the circles spin slowly?

Do you obtain a different effect when the speed increases?

What do you think is happening to make these visual effects?

Comments

It might be interesting to have a look at these short comments made by pupils in a large secondary school. Compare them with those you have made yourself.

When the circle was spinning quickly the black and white triangles became blurred and *grey* in colour.

As the circle spun in a clockwise direction we found that after looking at the centre for some seconds the pattern was reversed . . . it moved backwards.

When one boy placed his hand over the spinning circle his hand seemed to move.

When Circle 'X' was moving in a clockwise direction the centre seemed to spin towards the observer and we could see *yellow* lines radiating from the centre. At times . . . particularly when we half closed our eyes . . . these yellow images turned pink.

Two students closed their eyes, after studying the centre of the moving circle for some moments, and had the illusion of seeing a black circle with red flame-like forms issuing from it. The third student saw black lines turning one way and white lines going in the other direction. Three of us placed a plastic sheet, on which was an identical black and white circle, on top of the stationary circle and then stared hard at the centre for some seconds. When the plastic sheet was removed we could see black and white 'after-images'.

If we looked hard at the centre of the circle and then closed our eyes we saw white and grey straight lines radiating from the centre. These seemed to shimmer.

When we spun the circle in a counter-clockwise direction, pink lines appeared to radiate outwards, while the edge of the circle was a pale blue. But when we closed our eyes the effect was reversed.

If the circle was spinning in a counter-clockwise direction and we looked at it through half-closed eyes, the centre black ring seemed to be light blue in colour, although it was strictly black and white. The outside rings seemed to wave about and blue, yellow and orange lines appeared to radiate out from the centre of the circle.

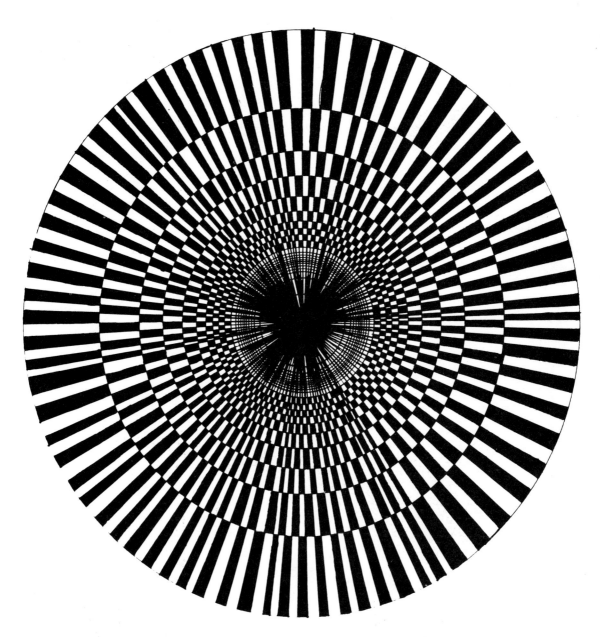

37　Circle designed by a secondary school pupil

38 Pen drawing by a secondary school pupil

Project ~~Displayed~~ Displaced
Black & white Stripes

② ① Vertical Cuts.

Concentric circles

Black & white diamonds
Black & white Squares

39 Useful visual thinking in the sketchbook

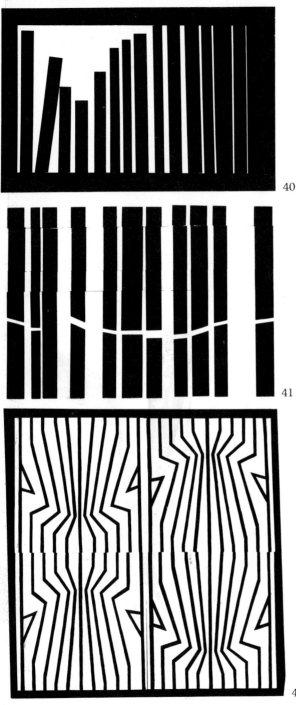

40

41

42

PROJECT 7
Vertical stripes

Materials
White card or cartridge (drawing) paper, black paper, glue, masking tape, ruler, scissors, large hardboard or fibreboard panel or oil painting canvas, fabric printing dyes, cheap cotton fabric, water based printing inks

Method
1 Take two pieces of paper 20 cm × 10 cm (8 in. × 4 in.) and call these 'A' and 'B' for easy reference.
2 Cut a number of strips of black paper 10 cm (4 in.) long but varying in width from 3 mm to 10 mm ($\frac{1}{8}$ in. to $\frac{3}{8}$ in.) and glue these so they form vertical stripes on the two rectangles. They should touch both the top and bottom edges. Leave white spaces – also of varying widths – but make sure enough black stripes are stuck down to cover the rectangles.
3 Take *rectangle 'A'* and make 5 or 6 vertical cuts with the scissors right through the design from left to right. These cuts should be straight ones.
4 Re-arrange the new shapes so that the vertical stripes are distorted. Now glue them onto a new piece of paper or card. Please use care and precision.

41 Slight developments
42 Variation – printed images
43 Variations
44 These stripes have been cut through and moved slightly
45 Variations of the vertical

5 Take *rectangle 'B'* and along each of the two 10 cm (4 in.) edges measure distances of 2 cm (1 in.). Fold the paper carefully (if card has been used it will be necessary to score it gently with a sharp knife on the reverse side so that a crisp edge is obtained). A simple zigzag or concertina will be the result.

Observations

Look at 'A' and 'B'. How do the final patterns differ from the first ones made using vertical stripes only?

Is 'A' more, or less, interesting and why?

What happens to 'B' when the folds are pressed closer together?

Possible developments

(a) Produce more rectangles of *vibrating* vertical stripes with black, white and one really bright colour.

(b) Do a large painting on hardboard or canvas.

(c) Try to obtain interesting variations on the theme of 'vertical stripes' by using more than one colour and by re-arranging your cut-out shapes as designs for work in collage and print-making.

(d) Produce one design as a textile print.

(e) Make a pattern of black stripes on a sheet of glass, clear plastic or acetate with black masking tape or glued-down paper. Place this over some of the earlier designs to obtain different optical effects.

(f) Translate one or two of these into work with three-dimensional materials making a small piece of sculpture.

(g) If you are working in a group why not paint a wall mural?

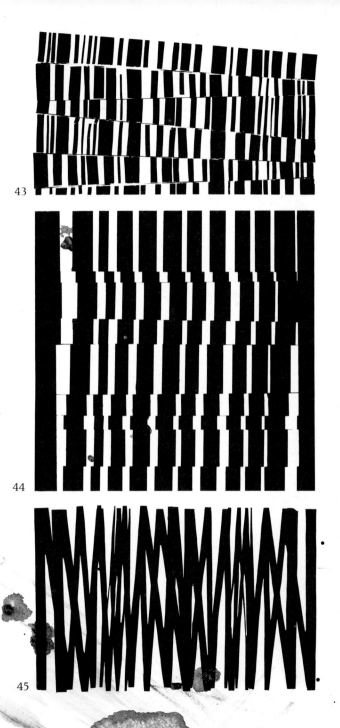

43

44

45

46 Stripe patterns made with cut paper

PROJECT 8
Variegated stripes

Materials
Black paper, white paper, newspaper or pages torn from a magazine, scissors, glue, fabric printing dyes, cheap cotton material

Method
1 Produce a number of long strips of black paper, white paper or newspaper.
2 Fold these (lengthwise) down the middle.
3 Working towards the fold, cut a series of shapes in the folded strips.
4 Open these out and glue on to a sheet of paper of contrasting colour to produce a pattern of related stripes. These stripes may be horizontal or vertical.
5 Make more designs by varying these ideas. For example, keep the small cut-out pieces and add these to some of the work.
6 Translate one design – using 'screen' or 'block' printing methods – on to a length of cheap cotton fabric producing a piece of printed textile.

47 Variegated stripes

48 Variations with stripes.

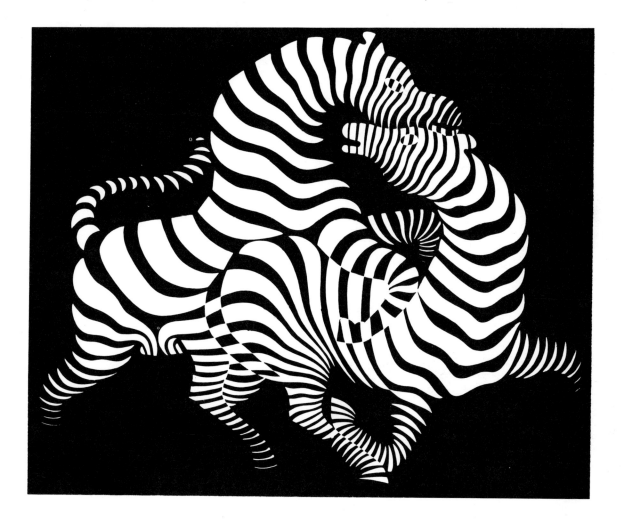

49 *Zebras* by Victor Vasarely. Indian ink, 1938. 40 cm × 60 cm
(15$\frac{3}{4}$ in. × 23$\frac{1}{2}$ in.) Showing the beautiful effects of Nature's own optical
patterning *Denise René Gallery, Paris*

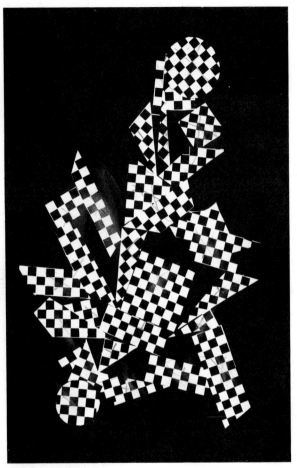

50 Squares

51 a b

PROJECT 9
Squares

Materials
White paper, black gummed paper, ruler, pencil, scissors

Method
1 Draw a square 24 cm × 24 cm ($9\frac{1}{2}$ in. × $9\frac{1}{2}$ in.) on white drawing paper.
2 Cut out 288 squares, each 1 cm square, of black gummed paper. Stick these on to the white square to form a chequer-board pattern.
3 Divide this pattern into about 30 geometric shapes – circles, squares, parallelograms, triangles, rectangles, etc – and cut these shapes out.
4 Use these shapes to compose a new design by gluing them on another piece of paper. Allow as many as possible to touch other shapes so that an interesting juxtaposition of images is formed.
5 Study the visual effects which this pattern produces.

PROJECT 10
Squares with inner motifs

Materials
Black and white paper, glue, scissors

Method
1 Cut out a number of identical squares (black and white).
2 Stick the white ones on the black squares as in figure 51a.
3 Use the new *double* motif to make a repeat pattern by sticking them on paper in close juxtaposition.
4 Produce another series and cut off the overhanging white triangular pieces so that you are left with simple black squares on which are white octagons.

5 Arrange these to form a mosaic-like design.

6 It is possible to introduce some variety by:

(a) putting a smaller octagon, a square or even a circular shape – in a contrasting colour – within the original one (see figure 51b) *or*

(b) making the final pattern resemble a chequer board.

See also colour plate 3 facing page 64.

53 Squares with inner motifs

52 Superimposed cut paper shapes. Design by a nine-year-old pupil in Montreal Canada

54 Experimenting with squares ▶

PROJECT 11
Repeated triangles

Materials
Black and white paper, glue, scissors

Method
1 Cut about 20 isosceles triangles out of black paper.
2 Arrange the triangles on white paper as a repeat pattern. Allow the triangles to touch.
3 Experiment with a number of variations in which, for example, the amount of white background is allowed to vary. Alternate triangles might even be inverted.
4 Be really inventive and try to create a number of new effects. Change the shape of the triangles to achieve more variety.

See also colour plate 3, facing page 64.

55 Complications

PROJECT 12
Maze-like patterns

Materials
Black felt-tipped pen, paper

Starting point
Draw with a pen a number of squares, circles and rectangles.

Development
Draw a *maze* within each shape. Start this either at the edge of the shape or at a point within it and end up close to the starting point.

PROJECT 13
Line patterns

Materials
Black paper or strong card, glue, scissors, used matchsticks or balsa wood strips

Method
1 Use matchsticks or equal pieces of balsa wood strip and compose a number of linear patterns by gluing the pieces on black paper or card.

Ideas
Regular steps
Irregular steps
Curves
Fences
1,2,3/1,2,3,4/1,2/1/1,2,3/1,2,3,4,5/1,2/1,2,3,4/1,2
2 Be inventive while remembering to make the patterns as optically irritating as possible.
3 Experiment with the materials and make a small three-dimensional 'optical' model.

Footnote to page 61
[1] 'Reflected' triangles form a kite-like shape. If you wish to vary your image, however, then allow your triangles to form a parallelogram.

PROJECT 14
Geometric models

Materials

Strong black card, hardboard or fibreboard, white thread (cotton, string or wire), ruler, black felt-tipped pen, small drill or sharp needle to make holes in the card

Ideas

1 Construct a simple three-dimensional model using two rectangular pieces of card (or hardboard). These should be of equal size and set at right angles to each other so that they form a firm base and backdrop and are joined along the edge where they meet.

2 Draw *two* large, identical triangles – one on the base (horizontal plane) the other on the backdrop (vertical plane), and having as a common base-line the edge where they join. Use a strong black line so that both triangles are easy to see. These are 'reflected' triangles.[1]

3 Draw an identical series of carefully measured lines in each triangle and make these run parallel with *one* side in each triangle.

4 Make small holes at the vertex of each triangle and also at the points where the parallel lines meet their sides.

5 Connect together both the triangles – from their vertices and the points on their sides – with thread.

NOTE

When you look at the complete model you will see some very interesting visual effects, which are produced as you look through the strings and see them in relation to the drawn lines on both the vertical and horizontal planes.

What do you think is happening?

What geometrical implications are involved?

56 Geometric model made by a secondary school pupil

57 Geometric model made by a secondary school pupil

61

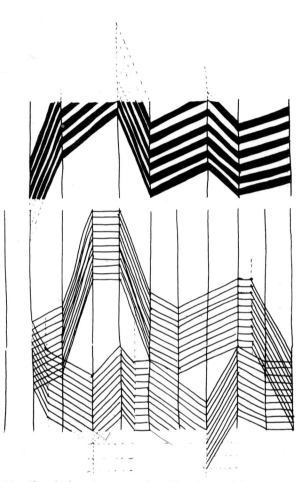

58 Sketch drawings stimulated by the models

Developments

(a) Have a look for similar linear constructions, such as bridges, in the local environment and make some sketches or photographs of them.

(b) Design a piece of sculpture (after referring to the work of Gabo, Moore and other sculptors), using hardboard, card and thread.

(c) Design and make a model of a new bridge, garage, or support for telegraph wires.

Three ideas for increasing optical interest

1 Using tracing paper or acetate sheet, trace some of the original designs in ink and place the traced op art patterns on top of the originals. This should provide some interesting results.

2 Make a stringed board:

(a) Take a piece of hardboard, fibreboard or strong card (say 380 mm × 380 mm (15 in. × 15 in.)).

(b) Glue a strip of wood underneath the edges. This wood should be 25 mm × 13 mm (1 in. × $\frac{1}{2}$ in.).

(c) Hammer small nails 6 mm ($\frac{1}{4}$ in.) from the outer edges at intervals of 6 mm ($\frac{1}{4}$ in.), and allow these to protrude at least 6 mm ($\frac{1}{4}$ in.).

(d) Use string or rubber bands stretched across the upper surface of the board from the nails (making sure that a space is left between them and the board's surface) to produce a pattern of parallel lines.

(e) Slide some of the original patterns underneath the string pattern and observe the optical changes.

(f) Now experiment by making other string patterns.

(3) Flickering lights – with one or two flashlights see what happens to the designs by shining lights onto them while at the same time turning the lights on and off quite rapidly.

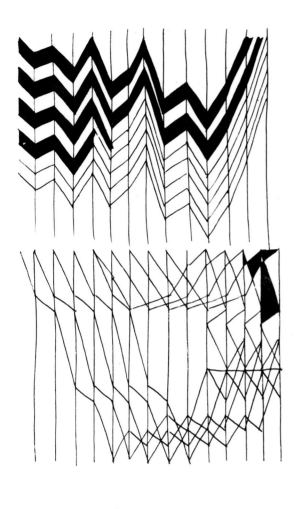

59 Sketches by the author showing possible developments from the three-dimensional models and the *figure/ground* phenomenon working well

An op art study

A third year student, Miss Jane Cowling, studying art as her main subject at St Mary's College of Education, Cheltenham, became interested in experimental developments with black and white designs. Her special area of study was painting, but she linked this closely with work in graphics and produced a large number of *optical designs* as paper 'cut-outs' before going on to screen printing techniques on fabric and paper. She developed a personal study of the subject and this extract is taken from it:

> The purpose of this personal study was to discover for myself the effects upon the eye of a variety of simple black and white images and their possible implication in optical art. Would some patterns, I asked myself, be more effective than others: and, if so, why?
>
> We know that certain black and white patterns produce a feeling of mental imbalance or disturbance, caused by rapid movements of the eye, and the subsequent after-images[1] result in a feeling of movement of the picture plane. The eye continually endeavours to find a point of rest. This kind of optical activity . . . which I had already discovered in the work of some op art painters . . . promoted the situation I wanted to investigate. So, I decided to use the simplest means and style at my disposal in carrying out my experiments.
>
> The first stage comprised the use of a very simple pattern . . . that of alternating black and white lines of equal width . . . on a small scale. These were produced as a paper 'pick-up' silk screen print, enabling the pattern to be produced in large numbers. This design then became the basic print for all the patterns which followed.
>
> The study itself progressed in a number of stages from the original basic pattern. Although this was an effective pattern on its own its *parallel line* motif lent itself well to many further uses and variations of the same theme.
>
> The second stage was a series of two overlapping prints. These were juxtaposed at varying angles and the resulting images were like 'moiré' illusions. Only the slightest difference in the angle of the prints produced quite a different and optically irritating pattern.
>
> It soon became apparent that the idea of overlapping prints could be taken much further and used in conjunction with the cutting up of other

[1] 'After-images' result if you look at a bright light for a few seconds then close your eyes.

◀60 Variations on a theme of parallel lines. A silk screen print
Page 65 61 Moiré illusions produced by 'overlapping' prints

Plate 3

Squares with inner motifs

Repeated triangles

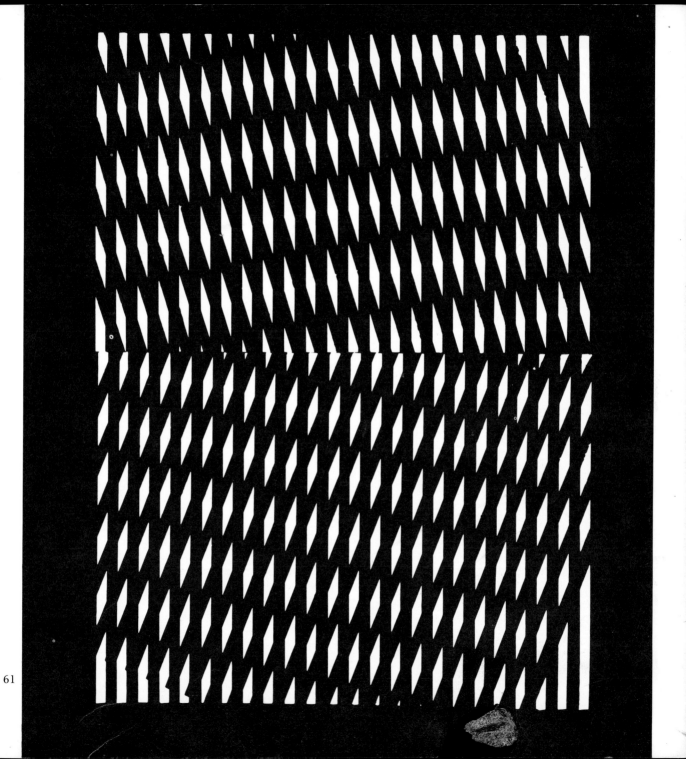

61

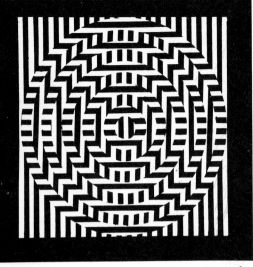

62 Right angles

63 *Turbulence*

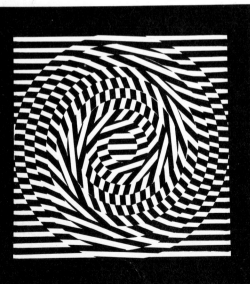

prints to make more complicated designs. The following stage consisted of the cutting out of concentric circles of equal distance. Firstly, from a single print, turning each circle the width of a space relative to its neighbour, and progressing from the centre outwards. Then I used two prints, one overlapped by alternate cut out circles from another print, which I placed on the first print at varying angles.

A further experiment was the overlapping of circles on a different background, a second motif, that of radiating lines.

What, then, can one say about these patterns? I have noted the following points. These designs were produced by what one could call a *mechanical process,* artistically they do not embody any feeling of emotion. Black is always positive and white the ground. Although on one design white positive markings seem to occur and give a three-dimensional effect, and I was fascinated to note that colour seems to be introduced by staring as steadily as possible at the centre of the design – to me, first yellow, then red. Another phenomenon which appears where there is none.

Each pattern has its own apparent movement. Again only the slightest variation on the same theme can produce a very different effect. Some designs do appear to have much more effect upon the eye and even seem to have more apparent movement than others. As in the first 'moiré' effect, those produced with the narrow parallel lines appear to be more effective than the wider overlapping lines which are just pattern. Scale is obviously important, too, and the smaller the scale the more startling the illusion of movement. On a very much larger scale the same patterns would probably not have the same effect, unless viewed from a long way off, as the eye would have difficulty in seeing the design as a whole and therefore there would not be the same apparent movement.

The contrast between black and white also contributes to the effect because of the extreme difference between the two tones. It would be interesting to discover whether the same designs produced with colours and similar tones would have the same effect upon the eyes as those in black and white.

This leads towards a further consideration of a study such as this one. Obviously there are endless permutations of this theme which could be pursued. There are many other directions worthy of investigation and one, for example, might be the use of reflective surfaces in conjunction with these patterns, then a progression into three dimensions and the distortion of regular shapes. The use of complementary colours and the further overlapping of designs, as well as other basic motives, could be explored.

It is possible that perhaps the simplest patterns offer the most effective results. Indeed, one could, in complicating the issue, lose the original idea.

In short, there would seem to be endless possibilities in a field in which artists such as Vasareley and Riley have already investigated a great many areas.

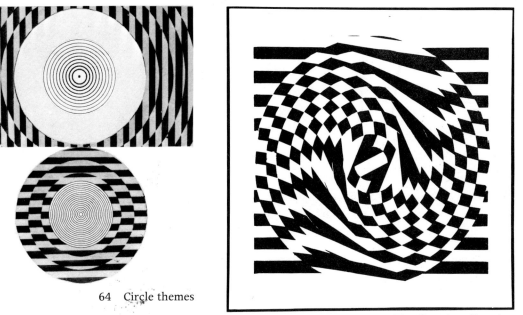

64 Circle themes

65 Changing direction

This personal study – which was a balance between practical work, reading and serious thinking – was certainly very worthwhile for this student. She produced well over seventy drawings and prints as well as a number of paintings. It shows what an individual can achieve if personal interest becomes aroused, and that op art can be a means to this end.

Overleaf
66 Ceramic tiles decorated with quivering optical patterns based on mathematical concepts *Manufacturer CEMER, Lecce, Italy*

Four advanced problems

The following ideas are rather more complex than those preceding them. They will require some degree of skill – both mathematical and artistic – but should prove of interest to pupils and students in high school and colleges. If the reader is confused, the illustrations will help, but it is suggested that they are ignored until the problems have been attempted.

Mathematical Experiment 1
in black and white

Materials

Graph paper, drawing paper, pen-and-ink, pencil, ruler, tracing paper, flexible ruler, if available

Method

1 Obtain a series of numbers, eg 2 4 7 11 16 22 29 37 46 56
The difference between 2 and 4 being 2, is increased to 3 between 4 and 7, and again increased to 4 between 7 and 11 and so on. At a convenient point (depending on the size and complexity of the finished drawing required) the difference can start to decrease again, eg 56 65 73 80 86 91 95 98 100
The difference between 56 and 65 being 9 is decreased to 8 between 65 and 73 and again decreased to 7 between 73 and 80 and so on.
2 Using the series thus obtained mark off these values on a vertical axis up one side of the graph paper and draw in parallel horizontal lines from these points, each line being the length of the vertical axis. This is a square divided up by a series of horizontal lines.
3 Transfer the drawing from graph paper to plain white drawing paper by using tracing paper and a ruler (carbon paper can be used if all the sheets of paper are taped over one another on to a drawing board). An optical effect will be achieved by accurately inking-in between alternate pairs of lines,
eg ink-in between 2 and 4
 leave white between 4 and 7
 ink-in between 7 and 11
 leave white between 11 and 16
 ink-in between 16 and 22, etc

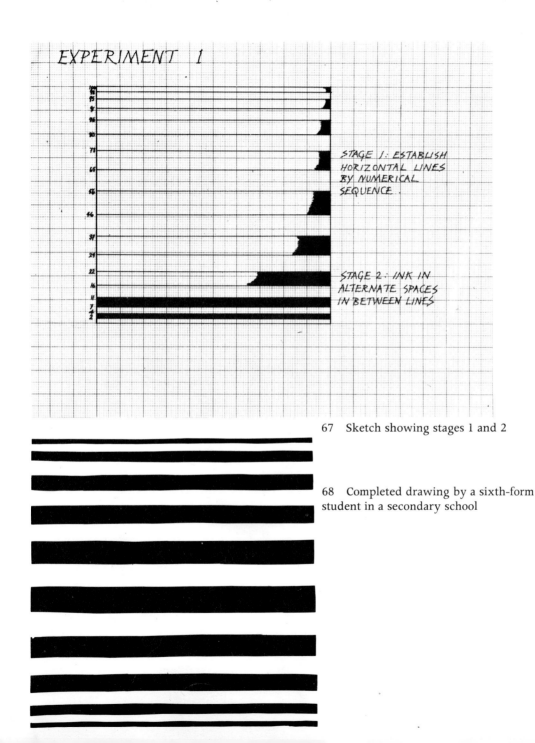

EXPERIMENT 1

STAGE 1: ESTABLISH
HORIZONTAL LINES
BY NUMERICAL
SEQUENCE.

STAGE 2: INK IN
ALTERNATE SPACES
IN BETWEEN LINES

67 Sketch showing stages 1 and 2

68 Completed drawing by a sixth-form
student in a secondary school

An even better effect will be achieved if the same series of numbers is marked off on the horizontal axis as well. This creates a grid of horizontal and vertical lines. By filling in alternate squares another optical pattern emerges.

After completing this project a student commented that the design gives an extremely effective optical illusion. 'The visual system', she said, 'reacts to the "overload" of the strongly repetitive pattern of squares and cannot find a stable centre of attention. This leads to confusion, and the eye cannot make up its mind where to focus. There appears to be a continually changing pattern within the picture space and the effect of movement produced seems to give the work a living personality of its own.'

Someone else exclaimed that the design itself makes weird optical effects and that it gave him the feeling that his eyes were slipping as they crossed each new shape.

Another student said: 'The first pattern gives the impression of being a series of columns which curve away into the distance at the edge of the paper, and this produces an impression of bulging into a dome at the centre and a shrinking into a curve at the edges. It also gives', she went on, 'a general illusion of movement when viewed from a corner point at eye level, and one may observe vibrating and string-like forms.'

It is apparent, then, as with all abstract work, that different people are affected by optical images in different ways. Different people 'see' different things, as I found out when asking some children to say something about one of the examples: 'It's a mirror shaking,' exclaimed one boy. 'No it isn't', interjected another, 'it's a machine kicking aside children's toys.' But they all agreed that it made their eyes 'go funny' if they looked at it for long as well as tending to 'snatch the eyes from one point to another so that it was impossible to look at the whole thing'.

One comment written in a student's notebook pointed out that the varying widths: '. . . give depth to the drawing and it appears that the thickest line is the nearest, with the others gradually receding in the distance. In this way a cylindrical effect results since the drawing gives the impression of the side view of a drum-shaped object. After viewing the drawing for some time the illusion of movement is also evident, and it appears that the thickest line is stable while the other lines radiate to and fro from this centre line.'

69 An effect of considerable
dazzle – a development of
the idea
70 Photographic experiments
to produce overlapping
patterns
71 Interesting variations

Mathematical Experiment 2 in black and white

Materials

Graph paper, drawing paper, pen-and-ink, pencil, ruler, tracing paper, flexible ruler

Having obtained a similar series of numbers, draw the curve of a simple equation such as $y = x^2 - 4$. By increasing or decreasing the original values of y by the numbers in the series, a series of curves parallel to the original curve can be obtained.

It is an advantage here to ensure a gradual curve for an optical effect, as will be obtained by making the units on the x axis twice or three times the size of the units on the y axis, and keeping the curve symmetrical, ie reading the values of x from x— minus 4 to x— −4. Again by transferring the drawing to plain white paper and filling-in alternate lines (or even odd shaped 'squares' if two graph curve series are superimposed at right angles to one another) an optical effect will be achieved.

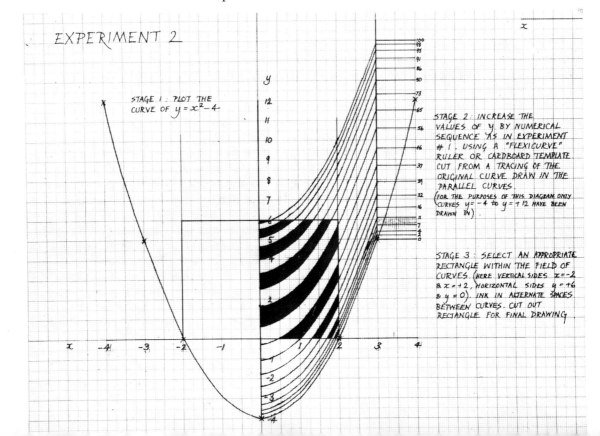

EXPERIMENT 2

STAGE 1 : PLOT THE CURVE OF $y = x^2 - 4$

STAGE 2 : INCREASE THE VALUES OF y BY NUMERICAL SEQUENCE AS IN EXPERIMENT # 1. USING A "FLEXICURVE" RULER OR CARDBOARD TEMPLATE CUT FROM A TRACING OF THE ORIGINAL CURVE DRAW IN THE PARALLEL CURVES. (FOR THE PURPOSES OF THIS DIAGRAM ONLY CURVES y=−4 to y=+12 HAVE BEEN DRAWN IN).

STAGE 3 : SELECT AN APPROPRIATE RECTANGLE WITHIN THE FIELD OF CURVES. (HERE VERTICAL SIDES x=−2 & x=+2, HORIZONTAL SIDES y=+6 & y=0). INK IN ALTERNATE SPACES BETWEEN CURVES. CUT OUT RECTANGLE FOR FINAL DRAWING.

73 Working with pen and ink

◀ 72 Sketch drawing on graph paper showing how one student worked
out the image

Mathematical Experiment 3 in black and white

Materials
Graph paper, drawing paper, pen-and-ink, pencil, ruler, tracing paper, flexible ruler

Method
A wavy curve can be obtained by using the equation $x = \sin \theta$. The same system as for Project 2 can then be employed. The visual steepness of the curve will depend upon the relative calibration of the axes $+1$ to -1 and 0 to 360°. A simple series of parallel curves can be developed simply by adding appropriate numbers in series to the $\sin \theta$ values obtained from logarithm tables.

Mathematical Experiment 4 in black and white

Materials
Graph paper (cm/mm), pencil, ruler, tracing paper, small brush, black ink

Method
1 Produce a curve using the formula $y = \sin(x)$
2 $x = 0°$ to $90°$
Reflect the resulting curve through $x = 90°$.
3 Rotate through 180° about $(x = 180°)$
$\qquad\qquad\qquad\qquad\qquad (y = 0)$
4 Produce further related curves as follows:
$\quad y = \sin(x + h) - k$
$\quad y = \sin(x + 2h) - 2k$
$\quad y = \sin(x + 3h) - 3k$
etc, so that you produce a number of horizontal and vertical curves.
5 Experiment with variations on this theme.
6 Try filling in alternate curves with black ink.

NOTE
Van Gogh was one of the first artists to convey movement vividly, and to do this he used wildly swirling brush strokes. This gave the appearance of movement. It is quite another thing to stimulate the eye so that we experience visual movement and this has been done by op artists such as Bridget Riley and Victor Vasareley who produce designs that shift and float and shimmer in producing violent illusionary movements.

5 How we see

1 The basis of vision and the science of the eye

Close your eyes. Without sight the world is diminished, shrunken. We use our eyes as windows through which we see the world

John Davy

The anatomy of the eye makes even the most complex camera look primitive. The eye is essentially a lens system and therefore is often said to be like a camera, but although it functions in a similar way, no internal picture is involved. The way in which we see is also dependent upon other sources of information besides the visual data that is captured by the eye. Recent experiments have shown that previous knowledge, coupled with reactions from our other senses, plays an important part in how we determine what we see. This can be affected by such experiences as touch or smell, or even our likes and dislikes. But before enlarging upon the fascinating aspects of perception, a closer study of each component of the eye will reveal some interesting facts and will help us to understand more clearly how it works mechanically.

The cornea, situated at the front of the eye, is transparent and is part of a tough but supple membrane called the *sclerotic* which encloses the eye. It is remarkable in that it has no blood supply and can, therefore, be thought of as being isolated from the rest of the body. The same is true of the lens and together they form a delicate and precise focusing system. The curvature of the cornea bends the light rays as they enter the eye and so assists the lens in focusing inverted images on a photo-sensitive system at the back of the eye. This screen is known as the *retina.*

The aqueous humour is a colourless fluid lying between the cornea and the iris. Its purpose is varied for it acts as a source of nourishment as well as helping the cornea to bend the rays of light. It also protects and supports the lens by hydrostatic suspension but, perhaps more importantly, it serves as a cleaning agent. The aqueous humour is secreted by the tear gland and is renewed about once every four hours. It passes across the eyeball, which it cleans before draining to the nose through a tiny hole at the side of the

A zonula
B aqueous humour
C iris
D pupil
E crystalline lens
F cornea
G conjunctiva
H ciliary muscle
I vitreous humour
J fovea
K optic nerve
L retina

74 The most important optical instrument which acts as a mediator between the mind and the world

lower eyelid. Such a cleaning process is common to all eyes with lenses and results from man's evolution, for this fluid is thought to be a substitute for the washing action of the sea. Indeed, human tears are themselves a re-creation of the ocean that once washed the first eyes. Tears provide a valuable lubricant too, particularly when the eye is irritated by small particles of dust or grit and since there is an enzyme present in tears, it also helps to disinfect the eye.

The iris, by virtue of the presence or absence of colouring pigments, is the most distinctive part of the eye. Its main function is one of protection, for it is a device which prevents too much light entering the eye. By contracting and expanding it alters the size of the pupil and controls the input of light. It has the ability to keep the amount of light which reaches the retina constant, and is responsible for the pupil opening wide in dim light and closing to a small aperture in bright light.

The way in which light is detected is a chemical one, for the sense cells in the retina contain chemicals which change according to the amount of light present. If too much light falls on the retina these chemicals are decomposed. Thus at dusk the pupils are wide open to allow the maximum amount of light to enter the eye, but should the headlights of a vehicle shine into the eye then all the chemical is decomposed and we are dazzled; our vision is impaired and we are unable to see until more chemicals have been replaced.

The pupil, apparently a solid, black object, is no more than a hole formed by the iris, the size of which is altered to adjust the amount of light passing through the lens and onto the retina. It is of interest to learn that the size of the pupil can indicate a person's feelings. Experiments have shown that large or dilated pupils signify interest, whilst small contracted pupils prove the opposite to be true. The special properties of both the iris and the pupil have held interest for poets and lovers, for literature abounds with phrases such as 'eyes like saucers', 'beady eyes', 'wide-eyed innocence' and so on. Such references rather confirm the view that the eye is more than just an optical instrument and that it is closely linked with the brain.

The lens is held in tension by a membrane called the *zonula,* an elastic structure that can be likened to an onion. Built up of thin layers from its centre the lens acts as a fine adjusting mechanism with the power to give very delicate and accurate control. It achieves this by changing its shape not, as one might suppose, its position as in a camera. The membrane supporting the lens can be tightened or loosened to allow the lens' surface enough flexibility – approximately 0·1 mm – to focus the eye on near or distant objects. The range over which the lens can change focus is known as the *accommodation range,* which varies considerably with a person's age. The decrease in focusing power with advancing age is due to the hardening of the cells as they become more separated from the blood system. Consequently as we become older these cells harden, finally die and the lens become stiff, which makes it difficult to change its shape for accommodation to different distances.

The retina deserves closer inspection for, unjustifiably, it has been thought of as a screen upon which images from the lens are formed. The retina has been carefully studied and it now seems that it is far more than just a thin, transparent lining upon which small, inverted images are focused. Optically speaking, the retina is back-

to-front, for light enters through a layer of nerve fibres which forms its front surface and then passes successively through three layers of supporting cells before it reaches the receptores – rods and cones – which lie at the back of the retina. So, like a camera film that has been put in the wrong way round, the retina is inside-out.

It is a very complex structure and is thought to be an outgrowth of the brain which has become sensitive to light. The three layers of cells at the front of the retina form part of the brain within the eye-ball itself, for many of these cells are directly connected to the brain by the fibres of the optic tract or optic nerve. Some of the incoming visual information and perception data is processed in the retina whilst other information is passed on to the brain for interpretation.

The very minute cells, numbering approximately 180 million, which are responsible for our sight are known as *rods* and *cones,* so named because of their shape. They are two quite distinct forms of sensory cells and are adapted to function over a wide range of differing light intensities. The rods give vision only in shades of grey because they are very sensitive to light, and they can only function, therefore, when the light intensity is low, for example, at night. 'Getting one's night-eyes' is a common expression and refers to the time taken for the eyes to adapt from a bright light to a dim one, and it normally takes the rods approximately half an hour or more to become completely sensitive.

In the eyes of nocturnal animals which require the power to 'see' at night there are a greater number of rods than cones, whereas, in human beings there are about six times as many cones than rods. The latter are concentrated at the edges of the retina and it is true to say that a star can be more easily seen if the eye is focused on a point to one side rather than directly on it. Cones, on the other hand, being sensitive to colour, have the ability to discriminate different light wavelengths as colour sensations and are more concentrated in the central part of the retina.

The fovea takes the lion's share in transducing the information contained in the retinal images. At this point on the retina an over-whelming mass of information is accumulated which can neither be useful nor desirable. The retina has to act; and to act requires the making of a decision based on the available information, and even if the retina cells were able to scan this information at an incredible speed there would still be a lapse of time before the required data

Plate 4

was transformed into the signals which are transmitted to the brain. The way in which the retina is able to compute such information is very complicated, but it is sufficient to say that there lies within the retina a system that, in effect, rejects certain information while protecting the brain from an overflow of signals.

2 The eye and the brain: the psychology of seeing

'Looking out through the eyes, the brain sees the world,' says Richard Gregory. What we see largely depends upon the assumptions we make about what is before us and seeing is not merely a matter of registering what is on the retina. The eye is dependent upon other senses and so the brain co-operates in defining the information passed to it. Our knowledge of the world is not limited to our visual experience of objects, for the brain has the capacity to enlarge upon the information which our eyes send to the *area stiata*. This region, to which the nerve fibres from the eyes eventually lead, lies at the back of the brain and also contains the *visual projection area* in which the memory of things previously seen is stored. Past experiences and anticipation of the future play a large part in augmenting sensory information, so that perception becomes a matter of suggestion and the testing of hypotheses.

Any image formed by the eye should be capable of being translated by the brain, for like a computer it accepts information and makes decisions accordingly. The human eyes are separated and each eye receives a different image of the observed object. This is more noticeable when looking at objects close at hand. When objects are viewed by each eye in turn they will appear to shift sideways leaving us 'one-eyed' for distances beyond approximately 3·6 m (20 ft).

Our visual system is able to bring these two different images together and in so doing creates a single perception of what we see. Cells in the retina, in conjunction with cells in the brain, respond to specific visual information and both contain mechanisms which analyse and select certain features of what we see. Single receptors in the retina only respond to such features when they are present in their receptor field. These include such features as *vertical edges; vertical edges that move; edges that move right or left only; specific*

Plate 4 facing page
These colours vibrate optically as they are of the same value, i.e. of the value 5 or 6 when black has the value of 0 and white the value of 10

81

colours; contours and contrasts, etc. These single rods and cones 'fire' or discharge minute electrical signals when they become active in response to features falling within their specific area of the retina. As stated previously, such a wealth of information, if passed on for interpretation, would have a chaotic effect upon our visual and mental processes. This does not happen, however, for the visual brain has its own built-in logic and preferences so that it can function adequately for both vision and thought. Within this region of the brain past visual and non-visual experiences and characteristics are stored. These affect the way in which we see the world, so that in the process of recalling past experiences, evaluating present images and anticipating future events, the brain is able to make a reasonable judgment in deciding what action should be taken in any given situation, hence the process by which an individual becomes aware of something called perception.

3 Perception of visual imagery

By and large physical objects in the world are constant whereas conditions of observation are variable

J. Newson, psychologist

Our thoughts and conceptions are primarily motivated by our senses and all the five senses are important channels of perception. The routine input of these sensory organs enables us continually to adjust to our all-embracing environment, for the information available is interpreted, as previously stated, according to our past, present and future. Perception, then, is selective for such things as knowledge of our past, recent events and even spoken words can exert a marked influence upon the information we choose to accept. This unique process of selection supplies the ingredients for our individual personality traits, emotional qualities and our particular way of thinking.

Visual imagery is a combination of vision and thought, for seeing and thinking are not independent and the phrase 'I see what you mean' indicates a real connection between the two. There also seems a close connection between visual and auditory stimulation which permits an 'association' between these senses. This integration enables the ear to witness what the eye sees and the eye to witness what the ear hears. Many people have 'colour hearing' and

experience imagery of colour when hearing sounds and in particular music. It is not uncommon to find a record-player installed in the art studio, for music can be a valuable aid in inducing both image and colour associations. Such associations were of primary importance in the work of Walt Disney, perhaps more notably in his film *Fantasia,* in which he achieved remarkable integration between sounds, music, movement, colours and visual images. It is the strengthening combination of all these aspects that made this film unique.

Colour association is not always stimulated by what we hear and there is a strong tendency to associate colour imagery with names, seasons, days of the week, letters of the alphabet, numbers and other things. Monday, for example, is a grey day because, as one writer put it, 'the return to the week's work rather darkens the outlook'. Numbers and, more frequently, sets of numbers are often seen as images in diagrammatical form and are spatially arranged so that for some the numbers from 1 to 10 are 'seen' as in the shape of a horseshoe or perhaps they lie in a straight line, whilst others may imagine them to take on the curved position.

Since all our sense organs are woven together and allow for a certain amount of 'cross-talk' between each, it follows that we can also experience such phenomena as taste-vision, tactile-vision and sound-vision. Imagery can also stem from our sense of smell. From my own experience I am able to recall quite vividly a certain book whenever I hear 'Pandora's Box' mentioned. I think of a blue, rather expensive book of children's stories and a certain finely-drawn illustration of Pandora opening the forbidden box. The pages were very thin and smooth to the touch and had a characteristic pleasant smell. In such a single perception a combination of a number of senses contribute in making the mental image possible.

What, then, are mental images? As mentioned above, when objects are not physically present they are represented indirectly by what we remember and know about them. This is done because past experiences deposit images which are handled as though they were the original images themselves. Such mental images are curiously private and less substantial than the originals and can correspond to every one of our sense organs. Thus even in the absence of external objects our thoughts may be clothed in concrete sensory form.

This somewhat simple view raises a number of questions but it is now realised that mental processes can also occur below the threshold of awareness. A great deal of what we notice and react to with our eyes involves no consciousness or so very little that we are unable to remember such things as whether or not we saw the time when we switched off the alarm-clock in the morning. For many this act heralds the daily tasks of dressing, washing and generally preparing for the day. Many of these are habit-forming and such experiences are not necessarily conscious and most certainly are not consciously remembered. As the well-known psychologist, Sir Cyril Burt states, 'Habits are nothing but associated movements, just as memories are associated thoughts.'

The notion that perception is just a carbon copy of the external world contained in the memory, implies that all human beings are blessed with the phenomenon of *eidetic recall,* more commonly known as *photographic memory.* Many artists who do not possess a photographic memory, however, are still able to acquire images whenever they so wish by making use of their unusually vivid imaginations. In his book *Experience and Behaviour,* Peter McKellar recalls the statement of a very young artist who expressed this ability in the following elegant terms, 'First I think and then I draws a line around my thinks'.

There continues to be much discussion as to whether images are influenced by intellectual thought or whether images can only influence images. The latter appears to be the more convincing, for confronted with an alien environment man is subjected to unfamiliar conditions of which he has very little knowledge. The moon, for example, is such an environment where the atmosphere, lighting conditions and the scale of objects are all different and astronauts have to rely, almost entirely, upon their sensory perceptions in order to orientate themselves.

How far learning is required for the basis of perception is still not certain, but babies develop their sense of perception only gradually. In the same way as a blind person has to 'learn to see' with his hands, so very young children first learn to recognise objects through their sense of touch. There is a particular case history of a man whose eyesight was restored after undergoing an operation, who would shut his eyes when confronted with an unfamiliar object and use his hands to feel the shape. He once remarked, 'Now that I've felt it, I can see.'

The perception of visual imagery has been a very important 'tool' in the hands of artists and craftsmen. A potter who decorates a round plate with motifs will nearly always use an odd number to complete his design. It is a 'rule of thumb' that such a practice is taught and the significance of this can be seen in the following diagrammatic form:

75 As a 'rule-of-thumb' an applied design should always enhance a particular form or shape; and not destroy it

The four dots are seen as a square, for each is mentally connected with an imaginary line, thereby destroying the roundness of the form on which they are placed. This effect would be considered by many as bad design. Hence, a potter thinks in odd numbers which lend themselves more readily to the roundness of his forms. The French Impressionists, such as Seurat and Paul Signac, painted their canvasses in such a way as to allow the onlooker to experience what has been called *induced perception*. Rudolf Arnheim expressed this in the following terms, 'Instead of spelling out the detailed shape of a human figure or a tree the Impressionists offered an approximation, a few strokes, which were not intended to create the illusion of the spelled-out figure or tree. Rather, in order to serve as the stimulus for the intended effect, the reduced pattern of strokes was to be perceived as such. The assembly of coloured strokes on the canvas was responded by the beholder with what can be described as a pattern of visual forces.'

76

77

78

4 Illusion

An illusion is an error in seeing based upon some sensory cue
Sidney Cohen

From the previous chapters it should be apparent that the world as we see it is far from the exact image of the physical world. Perception is variable and less than perfect so we are only able to perceive what we can conceive, which means that we tend to see only those things which fit into our framework of references. Our previous knowledge strongly determines how we see and thus the world is seen, not as it is, but as it ought to be.

In an illusory situation something appears to be other than it really is, whether it be the setting sun which appears to get larger and sometimes redder as it sinks towards the horizon, or the parallel lines of the railway track that seem to converge to a point in the distance. Such illusions are commonplace and many are completely acceptable to us, for we have learnt to live with our misinterpretations – our errors of perceptual judgment.

Most optical illusions are 'distortions' of one kind or another which are brought about by the direct result of a 'mis-seeing' of the facts presented. If we are to begin to understand the very nature of optical illusion we have to make a distinction between a number of differences which exist between such visual effects, for unlike common belief, they are not all optical illusions.

Visual distortions can be grouped into two main categories. Those like the Müller-Lyer arrow type are themselves distorted, for we see the two lines as being different in length whereas other figures such as the Hering fan type produce distortions but are not themselves distorted. The radiating lines of the background in the fan, bend the straight lines placed upon them, whereas the Müller-Lyer arrows themselves look wrong, because we accept that the left-hand figure is nearer to us than the one on the right. We are 'mis-seeing' the information, perhaps through our habit of seeing things the 'right' size, for the left-hand figure could be seen as the near-outside-corner of a building, the right-hand figure as the far-inside-corner of a room.

An 'ambiguous' figure, such as the Necker cube has two solutions and our perception is 'seen' changing from one moment to the next as the perspective of the cube reverses while we look at it, so that a

different corner is projected towards us, depending on the side your eye chooses as the front of the cube. The two solutions vie with one another for attention. This is also true of a 'reversible' figure, for we are unable to decide whether we are looking at the cubes from above or below. Such figures are not illusions for they do not involve a misinterpretation of the facts, neither do they involve seeing something that is not before us.

Another type of figure which is generally misplaced in the same category as illusions is called an 'impossible' figure. These figures are just what their name implies, that being a figure or object that has no unique solution, for although they can be drawn, they could not exist. Our perceptual system has to build up a three-dimensional world from what is essentially two-dimensional information and in searching for an answer comes to the conclusion that there is none.

79

These figures exploit the fact that what we see depends very largely upon the assumptions that we make upon what is before us.

In all these optical figures there is one common phenomenon that should not go unnoticed for it is most important in our understanding of illusion, and it is simply that the images on the retina remain the same, but our perceptual systems create alternate worlds out of them.

However, the opposite is true when an object is viewed some distance away from us. The image of that object on the retina *does change in size* as the distance between the viewer and that object changes. It is a simple fact from geometrical optics that the image of an object halves in size with each doubling of the distance of that object and likewise it doubles in size whenever its distance is halved. Therefore, the retinal image of a person who is standing 3 m (10 ft) away is twice that of a person standing 6 m (20 ft) away – but

Facing page

76 *The Müller-Lyer Arrow* The arrow on the left looks longer than the one on the right, yet the shafts are of equal length

77 *The Hering Fan* The radiating lines of the fan bend the straight lines placed upon them

78 *The Necker Cube* The eye is given two sets of perspective and is unable to make a choice between the two

79 *Impossible Figure* Incompatible information in the third dimension is given to the eye: two-dimensional lines giving three-dimensional information – incorrectly

80 *The Reversible Figure* The cubes change direction depending upon the squares your eye chooses as the front of the cube

people do not double in size as they move towards us! The important point here is that whilst the image of an object alters in size on the retina, it does not *appear* to grow smaller or larger for it still *looks* almost the same size.

Man is determined to see things his own way and consequently the eye is continually deceived because of its ingrained habit of estimating sizes by the way they contrast with sizes of other things around them.

The unusual perceptual process through which the brain is able to compensate for the changes in the size of the retinal images is called *constancy scaling* and we can see our own constancy scaling at work by carrying out this simple experiment. Look at your face in a mirror – a daily occurrence – and you will find that your face looks its normal size, a fact that we readily accept. Now breathe on the mirror until it is steamed-up and then trace the outline of your face. You will find that the size of your face is in fact about the size of a grapefruit.

To return to the illusions. There are many theories advanced which state the reasons and the cause of such distortions and it is recognised that all illusionary figures are flat projections of three-dimensional space, making them typical perspective drawings. Such linear perspective is nothing more than an illusion of three-dimensional objects in space which creates a suggestion of depth.

If an artist did not use perspective in his paintings we would find his work a little odd. But it is here that we have to consider a double reality for the painting itself is flat but the objects within the painting are portrayed existing in space. The artist, therefore, has to make us reject the flat, physical object – the canvas – whilst at the same time conveying the reality of his making – the actual painting – which represents something more than just areas of colour on a flat surface.

This is indeed a problem, for the artist has to contrive certain techniques in order that he may overcome the limitations brought about by the flat surface of his canvas. If the paint could be held somehow in suspension and the background, ie the canvas, removed, the artist's use of perspective techniques would achieve greater depth and his subject matter would take on a more realistic appearance, since neither the flat surface nor the texture of the canvas would impede our vision. Such a statement can be supported

by the evidence experienced when a colour-slide is seen through a hand-viewer, for the scene will look more three-dimensional than it does when it is projected onto a screen.

Furthermore, the artist cannot portray the actual world – the original three-dimensional scene – even if he uses the techniques of geometrical perspective which have come to be the most accepted and realistic way of representing the three-dimensional world. He is unable to see the world as it really is for several reasons.

One of the main problems lies within the perceptual system, namely *constancy scaling*. The artist's size constancy scaling will have compensated for any changes in the retinal images due to distance and thus he does not draw what he sees, but rather what is 'represented' by the images on his retina. A photograph represents the true geometrical perspective – and so too our retinal images – which is effectively demonstrated in photographs of tall buildings. As often as not these buildings will appear to lean rather drastically and yet this is true perspective, but through the process of our constancy scaling we are prevented from seeing this. We largely discount the shrinking perspective recorded on our retinas and in fact just see a tall building.

Another problem that confronts the artist stems from the basic fact that he has two eyes, but stereo vision only functions for comparatively near objects. A matchbox, for example, if held end-on about a foot away from the eyes will be seen to have four sides. But consider a perspective drawing of a matchbox; such a drawing if it is to be a 'realistic' one, can never show more than three sides.

Therefore, the artist has to use a modified perspective in order that he can overcome some of these problems and in a sense these perspective representations of the three-dimensional world are wrong. Such techniques are in effect, as John Davy points out, 'a one-eyed camera-view of the world', and we only have to shut one eye to realise how much the world immediately loses in depth and solidity.

In art, illusion does have a wide application, but in op art the optical effects that are employed and remain fundamental to this form of painting are not necessarily optical illusions. An illusionary figure, such as the Müller-Lyer arrow, is produced with only one intention, and that is to deceive the spectator.

The question has to be asked – 'Is the op artist making a conscious

effort to create optical illusions in order to bring about such a deception?' In reply it can be argued that if the artist does employ illusionary effects, it is not with the intention of creating illusions, but rather in order that the optical effects can stimulate the eye.

Cyril Barrett has made this distinction very clearly in his book on *Op Art*: 'If they (the artists) produce illusions, in the strict sense of deceiving, as opposed to stimulating, the eye, they have failed to produce op art, whatever else they may have succeeded in.'

6 Colour

Light, that first phenomenon of the world, reveals to us the spirit and living soul of the world through colours

Johannes Itten

An awareness of colour has always been of critical importance to the artist and since the middle of the nineteenth century, the development of the 'optical' qualities of this raw material – from which paintings are composed – has continued to grow. This development took place primarily within the art of painting itself and was manipulated to render a variety of different visual effects and even illusions. Indeed, whilst some 'op' artists still continue to confine themselves to canvas, there are others who are exploring the optical qualities in other materials such as coloured plastics, yarns and fabrics.

Colour is, in itself, a most complex and interesting subject that warrants deep investigation. However, a brief account of the historical background of painting from the beginning of the nineteenth century will reveal how the qualities of colour were exploited and developed, and how certain artists laid the foundations from which op art has been derived.

Scientific research into colour first appeared in 1810 when Goethe's major work on this subject was published. He was particularly interested in the colour effects of optical illusion and after-images – which remains one of the main characteristics of op art in its present form. Some twenty years later, Chevreul, as head of the dye laboratory at a Gobelin tapestry factory, published his paper on colour and this work, derived from his research into the juxtaposition of colours, was to become the scientific foundation of the Impressionist painters.

Earlier, the Renaissance painters had used colour in the 'traditional' way – colour being of secondary importance to shape and form – for their paintings were concerned with pictorial representation; but the influence of scientific research was to change this accepted practice.

Seurat, perhaps more than his contemporaries, was influenced by such research and his paintings show a systematic, even a scientific method of painting. He used small dots of colour, unrelated to

representational colour, which blended or mixed optically to produce paintings composed of almost 'abstract' colours.

The Impressionists were intensely interested in nature and devoted a great deal of time to the study of sunlight and its ever-changing effect upon the environment. Monet continually explored this phenomenon and in his paintings, light was the vital medium which revealed colour. Van Gogh, Gauguin and in particular Matisse (Post Impressionists) rejected the systematic use of the dot of colour and returned to the use of large, flatter areas of luminous colour, whilst Cézanne, who once remarked that 'light does not exist for the painter' developed colour as a construction, in which cold and warm and dull and intense colours were used to accomplish new and vivid harmonies.

Later, Klee and Kandinsky created canvasses to render a spiritual experience by means of shapes and colours. Kandinsky had long been interested in the expressive qualities of 'harmonies' and was concerned with the 'dynamism' of colour. He contended that every colour has its proper expressional value and that it is therefore possible to create meaningful realities without representing objects.

A logical development from this was shared by the Futurists who maintained that the most important element of dynamism and movement was colour. Amongst those who shared this view was Balla who produced perhaps the first experimental works of op art. But it is generally accepted that Marcel Duchamp – almost unconsciously – produced one of the earliest op paintings in 1936, when he painted *Fluttering Hearts,* in which the colours he used brought about a visible pulsating effect. Mondrian too, was aware of the 'kinetic' qualities of colour and in his painting *Broadway Boogie-Woogie,* 1942, the harmonic patterns show evidence of an optical vibration.

During the 1920s, an empirical approach to materials had been established by those artists who gathered at the Bauhaus in Weimar and later in Dessau. Here, the expressive qualities of colour were closely investigated and experiments in colour harmonies and contrast, interaction of colours, after-images, rhythms and relationships and the psychic effects of colour became the origin of op art. Since this time the characteristics of op art have continued to be developed and refined until it became an accepted form of painting in the latter half of the 1950s. Cyril Barrett has defined op art as 'an

attempt to produce pictures which give the impression of movement without actually moving'.

This apparent movement can be most effectively demonstrated by the use of black and white, making the strongest possible contrast – the black and white acting as complementary 'colours', and thereby achieving a most dramatic result. Most op artists have initially been concerned with the effects of the juxtaposition of black and white for they recognised that the exclusion of colour would also exclude the added problems that colour brings with it. From these studies which were based on 'periodic' structures, these being made up of simple geometric elements which were repeated many times, it was found that secondary patterns were produced, giving rise to undulations of the picture surface which set the painting in motion. In some cases, this instability also produced an impression of colour from the faintest suspicion of spectral tints to areas of brilliance which appeared to interweave, appearing and disappearing, through the repetitive structures.

Colour has long since been manipulated to achieve both maximum and minimum contrasts, and no more so than in op art, for colour has become another medium or dimension through which the artists work. The optical effects of the colours used are allowed to disrupt the surfaces of their canvasses, not in any arbitrary fashion, but in a carefully controlled way, often with great restraint and economy.

In order to gain a noticeable relationship between the colours, the optical effects that one colour has upon another have to be understood by the artist so that the required optical effects can be produced. Any colour once changed, either as the result of being placed on or against another colour – simultaneous contrast – or by 'after-images' which produce complementary colours – successive contrast – will create a chain reaction and so achieve a disruption of the surface structure of a painting. Even when only two or three colours are used in this way a wide range of colours can be induced.

The use of colour in this imaginative way is an indication of the gradual disappearance of old colour habits and old modes of thinking about colour. There is no doubt that during the last decade there has been a changing attitude towards the use of colour which has engendered a greater respect for the visual world. In op art, colour is used for the direct perceptual sensations it can evoke.

The paint itself is normally applied to the canvas in flat areas, for any indication of brush strokes tends to inhibit any optical effect and such areas are generally geometric in shape and have clearly defined boundaries. This 'hard-edge' technique of painting appears to produce the more striking optical effects.

Such striking effects can be obtained and occur when colours mix 'optically'. This mixing operation is performed visually in the eye and relies upon the varying distances between the spectator and the painting, for the colours appear to change, fuse or even move according to that distance. Such paintings are continually in a state of apparent movement and instability as the picture surface is broken up by a continuous change of colour, which seems to hover about the surface of the canvas and does not appear to lie on it.

How we, as individuals, see colour is also an important factor to consider, for we are not all equally sensitive to all colours. Hence, in op art the various sensations that are experienced will differ from person to person, for some will see certain colours receding where others see them advancing. This fact, coupled with the other aspects of colour previously mentioned produces the optical effects and sensations that have become associated with this form of painting and distinguishes it – as op art.

7 Op art in history

A detail from the Lindisfarne Gospel[1] shows the use of an interwoven pattern of lines which cross over and under one another in such a complicated way that we are intrigued and fascinated by the design. Our minds try to discover the system of the pattern and find it extremely difficult to resolve quickly. Many designs like this seem to have developed from using the extended bodies of long dragon-like creatures in a decorative manner (*figure 81*).

The surviving mosaic pictures from the Golden Age of the Byzantine Empire[2] in the sixth century AD were made of thousands of little cubes of glazed colour called *tesserae*. These were assembled into pictures to decorate the interior walls of churches, each one being set into the mortar base, giving a slightly uneven surface. As the light changes during the day and as the spectator moves about in front of these mosaics the light is reflected in different directions thus giving an irridescent quality (*figure 82*).

Neither of the works illustrated in figures 80 or 81 were made with the intention of confusing the spectator's senses in the same way as does modern op art. The 'manuscript' illustration was primarily a decorative device, a rich embellishment for a precious text rather than a picture puzzle. Similarly the mosaic did not set out to produce an op effect, but simply reflected the thought of a society which believed that truth was essentially spiritual and supernatural.

Some people would therefore argue that it is incorrect to use the adjective *op* when discussing works of art that were created before 1964–5 when the term first became popular. However, when we look at evidence from the past we are always looking at it from the point of view of our own place in history, from our own knowledge. We cannot recreate the past in its entirety, but must always relate it to our own experience.

One of the most boring aspects of learning anything about history can be a tradition of memorizing lists of names and dates. Kings,

[1] Lindisfarne Gospel (before AD 700), one of the finest examples of early Christian illuminated manuscripts still extant. British Museum, London.
[2] In AD 330 Emperor Constantine moved the capital of the Empire to Byzantium, renamed Constantinople, now Istanbul. The Byzantine Empire was the first Christian state.

81 A page from the Lindisfarne Gospel *The British Museum, London*

queens, wars and acts of parliament when treated in this way all too easily become 'the dead past', only brought to life occasionally by a play or a novel. However, it is more accurate to say that history can exist only in the present. The ways in which we interpret and understand events of the past are bound to be controlled by our present way of thinking, our own vocabulary of experience. Furthermore, no two independent books on the same subject will approach it in exactly the same way, and will often differ in their conclusions, especially if they were written at different times. History, therefore, is a continual recreation of the past in terms of, or in comparison with, the present. As a result it is possible to look back at certain works of art from previous centuries and sometimes find examples which we can relate to our present ideas of op art. We can never be 'objective' in our view of history because our interpretation of the past must largely be coloured by the influence of subsequent events that have created our own attitudes and ways of looking at things. History exists by virtue of the present.

The Renaissance

Prior to the advent of the Renaissance the concept of op art was impossible. In many ways it was the Renaissance that defined modern optical sensibility, the way in which we look at the world around us.

Obviously in order to make 'realistic' pictures of objects man had to discover laws such as that of perspective. Before the Renaissance the reality which is experienced through the senses was not considered so important. The early Greeks, especially the pre-Socratic philosophers and Plato (c 427 to 347 BC) believed that reality was something abstract, more on the spiritual plane than the evidence of our senses can realize. 'How can a picture of a box', Plato might have asked, 'show its true reality when at any one time we can only see two sides and the top or bottom of the box?' The early history of Christianity also considered that true reality was essentially spiritual. Often holy men of other religions such as Hinduism, as well as Christians, showed a contempt for the world as perceived through the senses, 'the world of the flesh'. It was only a change in attitude that came to see the world around us as a mirror of the creator's perfection that paved the way for a 'realistic' or illusionistic art. The function of all fine art, as distinct from the decorative arts

82 *Parting of Lot and Abraham*　Mosaic *c* 430 AD in the church of
Santa Maggiore, Rome　　　　　　　　　　*The Mansell Collection*

had, of course, always been related either to religion[1] or recording
the events of society. In neither case was imitating, in an illusion-
istic sense, considered the most important criterion.

　　Towards the close of the Middle Ages various religious move-
ments such as the friars, particularly the Franciscans,[2] sought to put
religion on a more practical, social and communicative level. The

[1] Including mythologies and religions other than Christian.
[2] Giotto's famous frescoes at Assisi commemorate the life of St Francis.

ordinary people had always been educated in the churches by symbolic art as well as by the words of the Church. Now, beginning with the work of Giotto (1266/7–1337) artists began to develop techniques of making their art appear more real and more vital, so that the audience could identify itself with the meaning of the work. As a result the period we know as the *early Renaissance,* in other words the one from Giotto to the end of the fifteenth century (which the Italians call the fourteen hundreds, or *Quattro Cento*), gradually discovered and established the laws which govern illusionism in art. In this they were somewhat influenced by the later Greeks, of the fifth century BC and after, who had been the first to tackle the same problem. One Greek sculptor[1] was recorded as having said that he sculpted men as they appeared to be, not as they 'really' (idealistically) were. In painting, however, of which very little survives, it is not certain how far the Greeks had actually developed illusion.

A number of artists after Giotto, including Masaccio (1401–28), Piero della Francesca (1410/20–92), Uccello (1396/7–1475) and others established the basic laws of illusionsim, that is to say : *how light can be used to model form ; how people and objects appear to get smaller the further they are from the onlooker ; and how parallel lines seem to converge in the distance.* Various mechanical aids were constructed to further this knowledge, including the *camera obscura* which, although only an aid to creating the illusion of depth on a flat surface, anticipated something of the principles involved in the invention of the photographic camera about four hundred years later. Towards the end of the *Quattro Cento* men like Leonardo da Vinci (1452–1519) contributed further to scientific discoveries of this nature. Thus in many ways the Renaissance, rather than being the re-birth of antique classical ideals as the word itself implies and as its contemporaries saw it, was the genesis of a modern way of thinking.

Lysippos, active after 370 BC. His works contributed to the development·of a greater realism in Greek sculpture of the last period of ancient Greek art (the Hellenistic period).

83 *The Rout of San Romano* by Ucello *c* 1450 *The National Gallery, London*

Effects of the Renaissance

Rules are made to be broken, or rather they are validated by the possibility of breaking them. It is not surprising, therefore, to find that once the rules of illusionistic art were established artists began to exploit them. In a sense the Mannerism (*c* 1520–1600) that followed the High Renaissance, also saw the early beginning of op art forms for this reason. Pictures using inconsistent perspective were now sometimes done on purpose, as puzzle-pictures.

Another important aftermath of the Renaissance was the start of a change in subject matter, even in the traditional purpose of fine art. The new interest in nature as experienced through the senses prepared the way for the eighteenth century, 'the Age of Reason' which was to follow the theatrical exuberance of Baroque and Rococo. Landscape on its own (rather than as background to

100

religious scenes or portraiture) made its appearance in the seventeenth century, and gradually assumed more and more importance. By the eighteenth century still lives (such as those by Chardin 1699–1779) were permissible as subject matter. Sensationalism, a philosophy that believes reality to exist only through the evidence of the senses, began to influence the arts, and the true emancipation of subject matter was now well under way. Eventually the conventions which had always governed the production of art were broken down and destroyed by the beginnings of the modern 'avant garde' tradition. And as freedom was established for *what* people could see in art, art was in a position to further its investigation into *how* people see.

The nineteenth century

The nineteenth century was prolific in the amount of research done into the problems of optics. In 1839, Chevreul, a Frenchman who worked at the Gobelins' tapestry factory, published a book entitled *On the Law of Simultaneous Colour Contrast*. He described how two different colours (or coloured wefts of silk in weaving) can interact when viewed at a distance. To explain this it is necessary to take two pieces of coloured card, one red, one blue, and hold them edge to edge. Where they meet the blue will appear greener, the red will appear more orange. See *Modular I* by Ray Thorburn, figure 3, in which he makes use of such colour effects. When the optic nerve is satiated by one colour it seeks compensation in its opposite colour. We call such pairs of colours complementary colours, eg red and green, yellow and violet, orange and blue. These three pairs are the primary complementary colours used by the scientist, philosopher and writer Goethe (1749–1832).

In 1867 Charles Blanc published his *Grammar of the Arts of Design*, in which he suggested putting colour on paper or canvas in little dots or stars. When seen at a distance two such colours mingle optically, that is to say in the eye, to produce the effect of a third colour. For instance a dot of blue and an adjacent dot of yellow will appear as green when seen from a certain distance. It is also important to note that a green produced in this way will seem brighter than a dot of green paint. Paint on its own works by the 'subtractive' principle of colour, ie it absorbs all the colours of the

spectrum[1] except the one which we see reflected back to us. Coloured light, however, works by the 'additive' law of colour; for instance blue and yellow light combine to make green. It was another scientist, Rood, in 1879, in his book *Moder Chromatics,* who finally made this distinction between the two laws of colour. He called attention to the fact that paintings will appear much brighter, more luminous, so long as we remain aware that there are actually two masses of colour producing a third one.

This was the principle used by Georges Seurat (1859–91) and the Pointillist or Neo-Impressionist school of painting in the 1880s and the 1890s. His painting of Mademoiselle Knoblock is constructed of many thousands of little dots of colour which inter-react with one another to produce a brilliant effect. Suerat's aim, however, was not to produce op art in the modern sense, but merely to produce a more vivid and colourful picture of life. The Impressionists of the 1870s had sought to paint what they saw in front of them as directly as possible. Cézanne (1839–1906) is reported to have described the painter Monet (1840–1926) as 'only an eye, but what an eye!' This attitude obviously made way for future investigations into the psychology of perception, the ways in which the eyes and the brain 'see'. Naturally the increasing amount of scientific interest in this field could offer artists new techniques to exploit.

The twentieth century

The modern idea of op art is usually thought of in terms of abstract painting. The first abstract picture is generally attributed to Wassilly Kandinsky (1866–1944) who painted it about 1910. *Abstract art* is a term used to describe a painting or any work of art that bears no immediate resemblance to anything seen in the normal way. Curiously enough, Kandinsky gave his first abstract pictures musical titles, and the connection between emotions, colours, and musical sounds as we have noted earlier in the book, have interested painters for some time. Seurat had been interested in similar ideas during the 1880s and so had some painters of the Fauve Movement[2] in the early 1900s. Think for example of how we talk of the 'blues'

[1] A prism will break up white light into its component colours which we call the spectrum.
[2] The painter Maurice de Vlaminck (1876–1958) was a violinist as well as a painter (and a racing cyclist!).

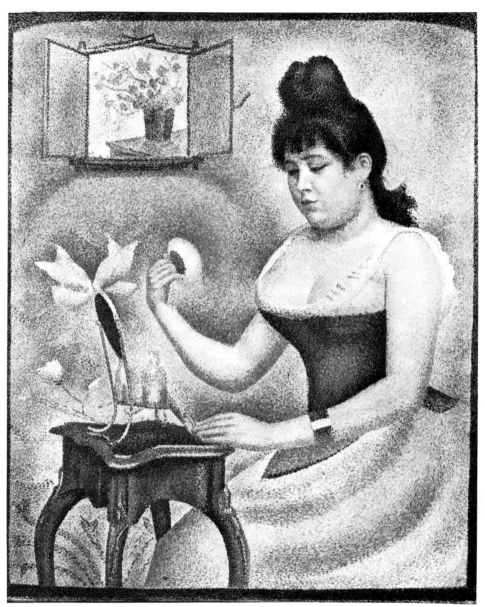

84 *Woman Powdering Herself* by Seurat 1889–90
Courtauld Institute Galleries, London

in describing a certain kind of music. At the same time scientists like Henri Poincaré (*Value of Science* 1906) began to consider the way in which mathematics relates to art. At the beginning of the century Einstein was working on his Theory of Relativity. Mathematics have always had a connection with the arts. The Greeks had used mathematical systems to determine the proportions of their idealized statues and their temples. The artist of the Middle Ages had thought that numbers reflected the divine nature of God.[1] The Renaissance had discovered the mathematics and geometry of perspective and illusion. According to legend, Pythagoras was both the inventor of mathematics and music. Is it surprising, then, that mathematics has been used so much in the art of the twentieth century?

[1] Ref. Emile Male *The Gothic Image*.

Notes on books for further study or reference

1 *Op Art* by Cyril Barrett, Studio Vista, 1970. A good general survey of the movement. Excellently illustrated. The best and most comprehensive survey of the subject available.
2 *Eye and Brain* by Richard Gregory, World University Library, 1966. A fascinating number of illustrations and information about optical problems. Many of these can be used as practical experiments.
3 *The Story of Art* by E. H. Gombrich, Phaidon 1956. Now in paperback. A famous general introduction to the history of art, much to be recommended.
4 *Abstract Painting* by M. Seuphor, Prentice Hall 1962. Now in paperback. Despite the fact that abstract art has now been with us for about sixty years, many people still shrink from the phrase and read it as being synonymous with 'modern art': art they dislike because they do not understand it. Michael Seuphor's book was originally written as an explanation of abstract painting and served its purpose well.
5 *Seurat and the Science of Painting* by W. Homer, MIT Press, Massachusetts 1964. An interesting and useful descriptions of the advances made in colour theory during the nineteenth century. He explains all the phenomena referred to in considerable detail and with good illustrations.
6 *Post-Impressionism* by John Rewald, Museum of Modern Art, New York. This also discusses the Pointillist school in detail.

7 *From Eugene Delacroix to Neo-Impressionism* by Paul Signac, Hermann, Paris 1964. This shows how optical science influenced the artists of the last century. The author was himself a friend and follower of Seurat.

8 *Concerning the Spiritual in Art* by W. Kandinsky. Documents of modern art, Wittenborn publications, New York. Written in 1912, this was the first ever real manifesto of abstract art, discussing colour, music and emotions, and the connections to be made between them.

9 *Art and Illusion* by E. H. Gombrich, Phaidon 1962. Chapter 8 is very informative on the 'ambiguities of the third dimension'.

10 *The Art of the Renaissance* by Peter and Linda Murray, Thames and Hudson. A well illustrated history of the development of illusionistic art.

11 *The New Architecture of the Bauhaus* by Walter Gropius, Faber. An excellent insight into the aims and ideas of Bauhaus education which served as a background to Josef Albers and Laszlo Moholy-Nagy.

12 *Studio International* Much information and many illustrations can be found by consulting back numbers of popular art magazines and periodicals.

The following paintings are of particular interest:

The National Gallery, London

Renaissance
Masaccio *Madonna and Child*. This shows one of the earliest consistent images using light and shade in the fifteenth century. In this Masaccio is to be considered as Giotto's real successor.

Piero della Francesca *Nativity*. Despite the rather bad condition of the grass in the foreground, in the left hand side of the painting one can see the landscape diminishing into the far distance.

Ucello was so fascinated by perspective that his means of achieving it sometimes appear rather forced. *The Rout of San Romano* is one of three panels commemorating the battle, the others being in Florence and in Paris. The dead man in armour lying on the ground has fallen neatly, so as to indicate the direction of the picture's vanishing point.

Jan van Eyck's *Betrothal of the Arnolfini* has a wealth of detail typical of the Northern Renaissance. The artist's intention was to paint as accurately as possible – every hair on the dog is faithfully recorded.

Eighteenth century
Chardin *The Young Schoolmistress* shows how subject matter changed gradually to include everyday objects and people.

Nineteenth century
Claude Monet's *Landscape at Vetheuil* shows how the Impressionists concentrated upon recording nature as they saw it at a particular moment in time. Here he captures the effect of sunlight on snow.

Seurat's *Bathers* was his first major large-scale work. His early paintings do not, as you can see, consist of evenly sized dots of paint, but simply irregular short brush marks. As one steps back from it the painting appears richer.

The Courtauld Institute Gallery, London

This gallery also shows a fine collection of Impressionists and Post-Impressionists, including Monet's *Autumn at Argenteuil,* with the shimmering autumn leaves stirred by the wind in the sunlight by the river. Seurat's *Woman Powdering Herself* shows a later example of Pointillist technique. Note how the artist has painted a frame on the picture surface composing it of dots of colour complementary to those of the picture itself, and as it were isolating it.

The Tate Gallery, London

Best represents the *twentieth century,* and shows work by most of the modern artists discussed above. Note particularly Josef Albers *Homage to the Square.* In this series of pictures he investigated the implications of depth given by certain colours. There are also works by Victor Vasarely, Jeffrey Steele and Bridget Riley.

Bibliography

ARNHEIM, Rudolph *Art and Visual Perception,* Faber, London 1969.

ARNHEIM, Rudolph 'Image and Thought' in *Sign, Image and Symbol,* Editor Gyorgy Kepes, Studio Vista, London 1966.

BANHAM, Reyner *Theory and Design in the First Machine Age,* The Architectural Press, London 1960.

BARRETT, Cyril *Op Art,* Studio Vista, London 1970.

COHEN, Sidney *Drugs of Hallucination,* Paladin 1970 (2nd edition).

COMPTON, Michael *Optical and Kinetic Art,* Tate Gallery, London 1967.

CRAFT, Robert *Stravinsky in Conversation with Robert Craft,* Pelican Books, Harmondsworth.

DAVY, John and DOYLE, Christine 'There's More to Seeing than Looking' in *The Observer Colour Supplement,* London 7 December 1969.

GIBSON, James J 'A Theory of Pictorial Perception' in *Sign, Image and Symbol,* Editor Gyorgy Kepes, Studio Vista, London 1966

GOMBRICH, E H *Art and Illusion,* Phaidon Press, London 1962

GOMBRICH, E H *The Story of Art,* Phaidon Press, London 1967

GREGORY, Richard *Eye and Brain,* World University Library, London 1963

GREGORY, Richard *The Eye and The Brain,* Weidenfeld and Nicolson, London 1966

GROPIUS, Walter *The New Architecture of the Bauhaus,* Faber and Faber, London 1965

HOMER, W *Seurat and the Science of Painting,* MIT Press, Massachusetts 1964

ITTEN, Johannes *The Elements of Colour* (A treatise on the colour system of Johannes Itten based on his book *The Art of Colour*) Van Nostrand Reinhold, London and New York 1970.

JANSEN, H W *A History of Art,* Thames and Hudson, London 1962.

KANDINSKI, W *Concerning the Spiritual in Art,* Wittenborn Publications, New York 1947

KEPES, Gyorgy (Editor) *Sign, Image and Symbol* – Vision and Value Series, Studio Vista, London 1966

LAZZARO, G di san *Klee: His Life and Work,* Thames and Hudson, London 1964

MALE, Emile *The Gothic Image,* Collins, London 1961.

McKELLER, Peter *Experience and Behaviour,* London 1968

McLUHAN, Marshall *Understanding Media,* Sphere Library, London 1969.

MHOLY-NAGY, Lazlo *The New Vision,* Wittenborn Inc, New York 1964.

MULVEY, Frank *Graphic Perception of Space,* Studio Vista, London and Reinhold Book Corporation, New York 1969.

MURRAY, Peter and Linda *The Art of the Renaissance,* Thames and Hudson, London 1963.

PAROLA, Rene *Optical Art,* Van Nostrand Reinhold, London and New York.

REWALD, John *Post-Impressionism,* Museum of Modern Art, New York 1962.

RÖTTGER, KLANT and SALZMANN *Surfaces in Creative Design,* Batsford, London 1970.

RYDZEWSKI, Pamela *Art and Human Experience* (The Commonwealth and International Library) Pergamon Press, London 1967.

SAUSMAREZ, Maurice de *Basic Design: the dynamics of visual form,* Studio Vista, London 1964.

SAUSMAREZ. Maurice de *Bridget Riley,* Studio Vista, London 1970.

SEITZ, William C *The Responsive Eye,* The Museum of Modern Art, New York (The Case-Hoyt Corp, Rochester, New York) 1966.

SEUPHOR, Michael *Abstract Painting,* Prentice Hall International, London 1962.

SEUPHOR, Michael *A Dictionary of Abstract Painting,* Methuen, London 1960.

SIGNAC, Paul *From Eugene Delacroix to Neo-Impressionism,* Hermann, Paris 1964.

SLADE, Richard *Geometrical Patterns,* Faber, London 1970.

SLOANE. Patricia *Colour, basic principles and new directions,* Studio Vista, London.

SPIES, Werner *Vasarely,* Abrams H.N. Inc, New York 1969.

THOMPSON, David 'Bridget Riley' in *Studio International,* July/August 1971, Volume 182, No. 935, pp. 16–21.

VINES, A and REES, N *Plant and Animal Biology,* Volume 2, Pitman.

WILSON, John Rowan 'The Mind' in *Time-Life International* (*Nederland*) *N.V.,* Life Science Library 1968.

Other references
Catalogue, XI Bienal de Sao Paulo 1971.
Studio International, Volume 166, 1963; Volume 172, 1966.

Index